IMAGES
of America

MOUNT VERNON

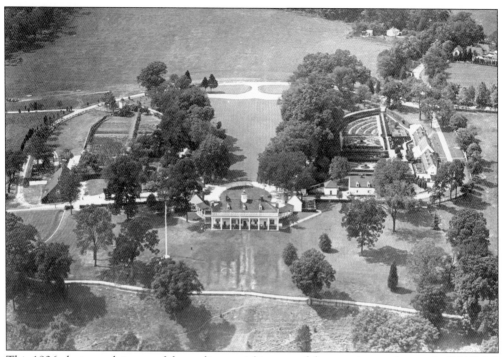

This 1926 photograph is one of the earliest aerial images of the mansion and grounds. (NARA.)

IMAGES
of America

MOUNT VERNON

Patrick L. O'Neill

Published by Arcadia Publishing
an imprint of Tempus Publishing Inc.
Charleston SC, Chicago, Portsmouth NH, San Francisco

Printed in Great Britain

Library of Congress Catalog Card Number: 2003112426

For all general information contact Arcadia Publishing at:
Telephone 843-853-2070
Fax 843-853-0044
E-mail sales@arcadiapublishing.com
For customer service and orders:
Toll-Free 1-888-313-2665

Visit us on the internet at http://www.arcadiapublishing.com

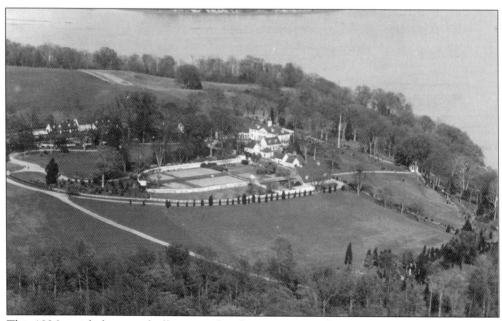

This 1926 aerial photograph illustrates the close proximity of Mount Vernon to the Potomac River. (GM.)

CONTENTS

ACKNOWLEDGMENTS

Compiling this book has been truly a labor of love and I want to thank a number of people. First, I would like to thank my wife Diane, for her encouragement to take on the project, her constant support, editing, and bolstering my ego when I needed it most. Also, I thank my daughter Bridget for letting me work at the computer when she wanted to play and go outside. Edward Redmond deserves a huge thank you for his support and knowledge, not only as a Washington scholar, but also for caring about all of my research endeavors. R. Randall Patrick performed wonders by producing the original computer graphics in this book, as well as providing enthusiasm. Edith Sprouse also deserves special thanks by providing her usual flow of historic information to keep me on my toes and on the straight and narrow path!

Special acknowledgements go out to Brian Conley, C.K. Gailey, Elizabeth Crowell, Linda Blank, Ron Chase, Brian Tuminario, Erin Scheithe, Dawn Bonner, Marcia Klein, Fred and Julia Shields, The Mount Vernon Ladies' Association, the Virginia Room of the Fairfax Public Library, the Geography and Map Division and the Prints and Photographs Division of the Library of Congress. And, finally, thanks to Esther White from Mount Vernon Archaeology who recommended to Arcadia Publishing that they contact me to write this book.

This book is dedicated to my parents, Lenora Luebbers O'Neill (1927–1992) and Eugene "Jim" Edward O'Neill (1927–1998), for without their loving education and strength, I would be a much different person today.

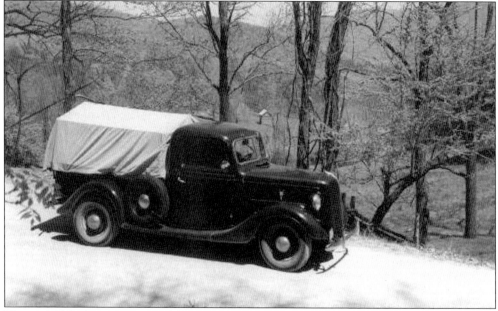

This is Mildred, my 1937 Ford half ton pickup I have owned for over 25 years, since my freshman year in high school. We tool around town and even take her camping, as seen in this 1998 photograph near Seneca Rocks, West Virginia.

INTRODUCTION

Welcome to my book on the Mount Vernon neighborhood. My concept of this book was to present a side of Mount Vernon and George Washington's life that few books and articles have covered: the area just outside the gates of where Washington lived and died. The impact the Washingtons had on the surrounding area would be felt for many years, on both the existing neighbors and those who moved to the area because of their presence. An index map of the places discussed here is provided at the end of the book, showing the locations of these overlooked places and the people who built them.

Chapter one presents George Washington as both a gentleman farmer and an eloquent politician, showing the ties he felt to the earth were strong. Washington, through the development of Mount Vernon, raised himself to the upper echelon of Virginia society. Even if he had not been the acknowledged victor of the American Revolution or the first president of the United States, Mount Vernon would have still been one of the largest and most organized farms in the Mid-Atlantic region. However, if he had not been the victor and President, the land probably would not be preserved today.

While many people lived near Mount Vernon during George Washington's tenure at the plantation, probably the most influential nearby family was the Fairfax family on Belvoir Neck immediately to the south of Mount Vernon, as presented in chapter two. From Washington's early youth until his death and burial, the Fairfax family guided him, helped him into the political and social spotlight, trusted him with their personal affairs, and even made George and Martha Washington godparents of some of their children. Beyond Belvoir to the south lay Mason Neck, the home of George Mason, author of the Virginia Bill of Rights, which was later used as a guide for the U.S. Constitution's Bill of Rights. The impact Washington and Mason had on each other's lives was great. As much as the Fairfax family helped develop George Washington's private life, Mason helped form the country Washington protected and led.

When George Washington died on December 14, 1799, his will gave use of his estate to his wife Martha, who followed him in death in 1801. Upon her death, the late President's will came into effect and the farms comprising the Mount Vernon estate were passed on to a nephew, two great-nephews, and his step-granddaughter. Chapter three follows the distribution of the Mount Vernon estate from these four individuals to the acquisition of the mansion by the Mount Vernon Ladies' Association and the coming of the Quakers in the 1840s and 1850s. Quakers, predominately from Burlington County, New Jersey, moved to the region and purchased a large portion of the outlying farms around the main Mount Vernon farm. The Quaker community around Mount Vernon demonstrated that non-slave labor and ingenuity could help revitalize the local economy. The Washington heirs of Mount Vernon honored the legacy of the late President by passing the land he cared for so deeply to the Quakers and other good stewards who would allow the neighborhood to continue as an agricultural-based community for almost 150 years after he died.

Chapter four presents the 200-year military presence around Mount Vernon, beginning with the construction of Fort Washington in the early 1800s, the Battle of the White House in September 1814, and the Civil War. Fort Hunt was built in 1898 on River Farm, one of Washington's outlying farms around Mount Vernon. Then, in 1918, when the Army Corps of Engineers built Camp A.A. Humphreys on neighboring Belvoir Neck, the Mount Vernon Neighborhood underwent the largest change in its history at one time. Renamed Fort

Humphreys and now known as Fort Belvoir, the post provides protection for the Military District of Washington.

The region within a few miles' radius around Mount Vernon contained many colonial and 19th-century farms and estates, both in Virginia and Maryland, which are described in detail in Chapter five. There were many more estates in the region around Mount Vernon than could possibly be presented in this book, and their omission was an unfortunate necessity. Furthermore, I could only include properties of which I had access to photographs of the buildings. Perhaps this book will provide the basis for a more detailed analysis of the remaining houses and their owners.

Chapter six is my personal favorite in this book, showing the rich history involved with 200-plus years of tourists visiting Mount Vernon to pay homage to George Washington and his home. This patronage started upon his death in 1799, and today brings hundreds of thousands of tourists per year to Mount Vernon. I almost wanted to name this chapter "Planes, Trains, and Automobiles" because it applies so well, but you get the idea.

This volume contains over 225 images of Mount Vernon and her surrounding neighborhood, with dozens of previously unpublished photographs. It is my sincerest hope that when you finish reading this book, you have not only been pleased with the images of the houses, maps, and people, but that you also have enjoyed a history lesson of what transpired in George Washington's backyard.

Patrick L. O'Neill
September 2003

One

GEORGE WASHINGTON AND THE DEVELOPMENT OF MOUNT VERNON

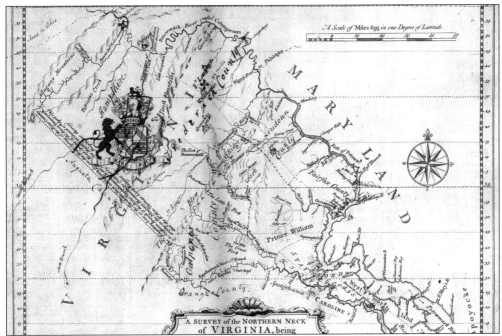

The Northern Neck Proprietary was a five million–acre tract between the Potomac and Rappahannock Rivers in the northern Virginia Colony granted to several Culpeper family cousins and five companions in 1649 by King Charles II. For almost 100 years, the right to own the grant was fought in court, and the Culpeper group won. Mount Vernon is located to the left of the "N" of Maryland in this 1747 map. (GM.)

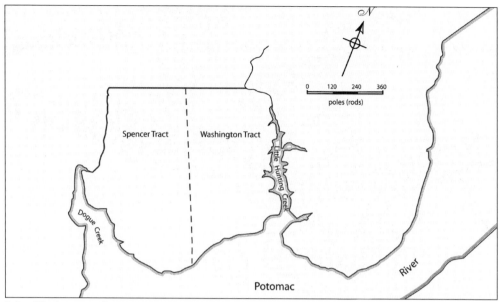

John Washington (George Washington's great-grandfather) and Nicholas Spencer patented a 5,000-acre tract in 1674, between Dogue and Little Hunting Creeks on the west bank of the Potomac, the first patent in the Proprietary ledgers. The two families would later split the tract perpendicular to the river for an equal share of waterfront. The Washingtons kept their half of the neck intact while the Spencers began selling parcels. (RP.)

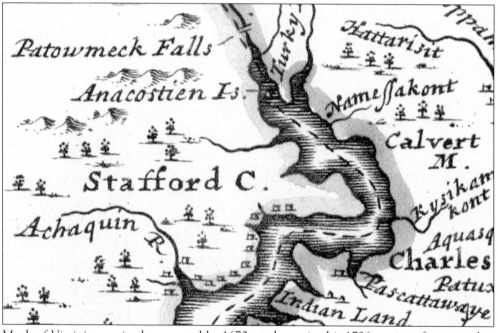

Much of Virginia remained unmapped by 1670, as shown in this 1736 reprint of cartographer Augustine Herrman's map. Herrman placed several Native American villages along the west side of the Potomac River north of the Achaquin River (Occoquan River) a few miles south of the Washington family tract. The Washington tenants and the Native Americans may have had a relatively peaceful existence, but little survives in the historical record of that time period. (DR.)

10

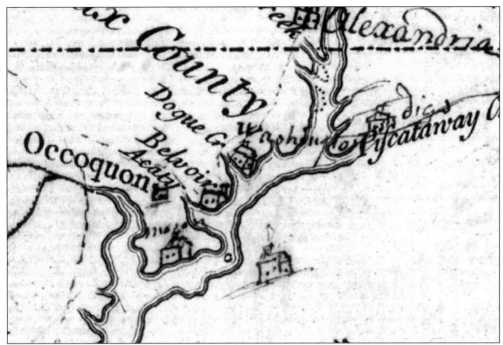

John Washington left the land to his son Lawrence, whose son Augustine left it to his son Lawrence, George Washington's half-brother. This detail of the 1747 map of the Proprietary shows the location of the Washington land on Dogue Creek while still in the possession of the younger Lawrence Washington. (GM.)

In 1748, young 16-year-old George Washington, who had just learned to survey, joined his neighbor and close friend, George William Fairfax, on a survey party heading west. Fairfax's uncle, Thomas, the sixth Lord Fairfax, hired the young Washington to help survey the Northern Neck Proprietary. The trip and association with Fairfax was the beginning of Washington's climb to fame and access to the upper echelons of Virginia society. (PP.)

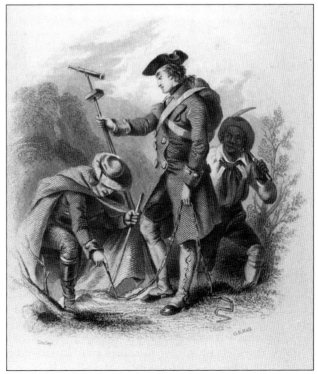

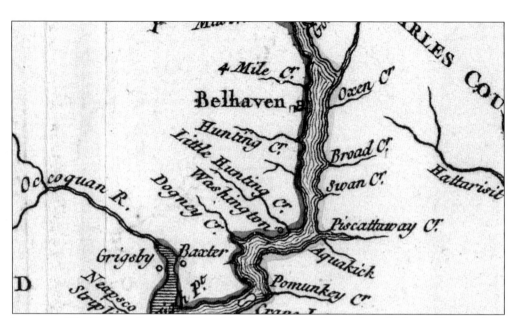

Lawrence Washington died in 1752 and his half-brother George leased Mount Vernon from Lawrence's widow, Anne Fairfax Washington, the sister of George William Fairfax. The Washington estate was still one of the few plantations shown on this 1755 map of northern Virginia, indicating its size and importance compared to the surrounding landholdings. Belhaven, which would become Alexandria, was the only major nearby town. (DR.)

First a one-and-a-half-story dwelling, Mount Vernon was modified to become one of the largest homes in northern Virginia. Though George Washington was relatively new to the social and political scene, the plantation was still the only one drafted between "Dogney Creek" (instead of Dogue) and Alexandria on this 1755 map. By that time, while aide to General Braddock, Washington began to rise in the military ranks. (GM.)

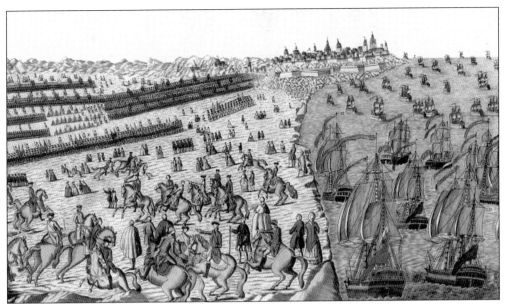

Washington spent almost half of his adult life away from Mount Vernon in either the military or elected political office. During one of his last major military campaigns, his troops traveled past Mount Vernon to fight the British Army at Yorktown in 1781, as depicted in this image. When Washington accepted the British surrender in October 1781, Cornwallis was too sick to meet, sending a stand-in for the formal surrender. (PP.)

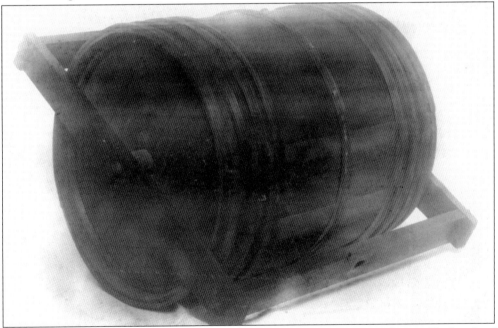

Like many of his neighbors, Washington's early main cash crop was tobacco. Hogheads of tobacco, wooden barrels with a handle to roll it along the ground, were pulled along "rolling" roads to ships and transported to the marketplace or overseas. By the 1760s, Washington realized that tobacco was depleting the soil of nutrients and turned to other means of agricultural stability to replenish the soil. (VR.)

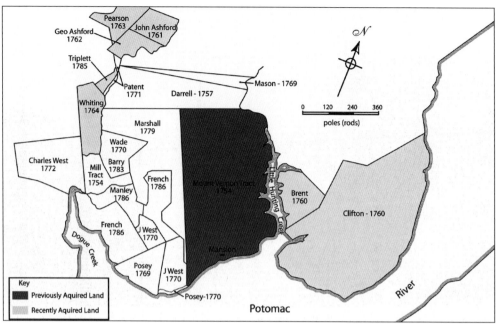

To increase crop production, Washington needed more acreage, so between 1754 and 1786, he bought back all of the acreage the Spencer family had received in the late 1600s split with his great-grandfather John Washington. Most purchases of land occurred after he married Martha Custis in 1759, probably with the influx of more working capital. By 1764, he had purchased the land across Little Hunting Creek and along Dogue Creek. (RP.)

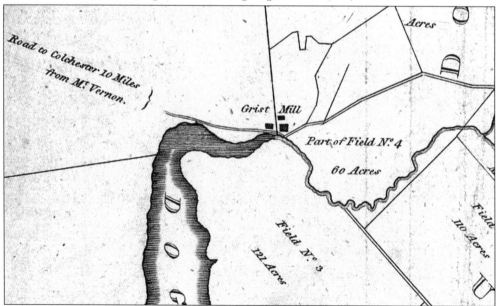

When Washington bought the mill tract in 1754, a small mill already existed, which he replaced in 1770, as shown in this 1801 map. The new mill had a long millrace, or canal, to run the mill wheel fed with grains from his growing network of farms, which increased his personal income and financial independence. Washington's purchase of the tracts along Dogue Creek enabled him to build the longer millrace. (GM.)

14

The grist mill operated for many years and was joined by a distillery in 1797. The distillery was a huge money maker for Washington but was closed in 1799 upon his death. Local Quakers tore down the mill in the 1850s just before the Civil War. By the 1930s, when this photograph was taken, a few outbuildings and a house occupied the mill grounds. (WL.)

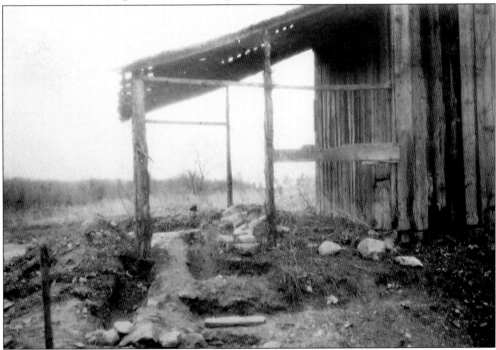

During the mill's reconstruction for the bicentennial celebration of Washington's birth in 1932, archaeologists uncovered the mill foundation under one of the wood frame outbuildings. To the joy of the historians, the mill's location was confirmed by archival records to be very accurate, greatly aiding the reconstruction efforts. (WL.)

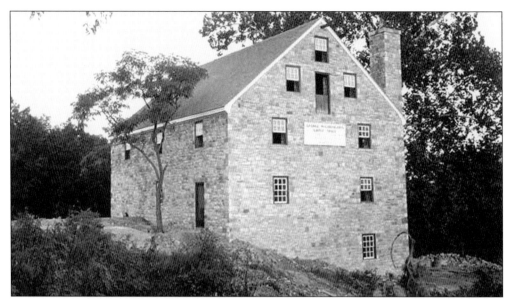

In 1932, when this photograph was taken, the reconstruction of the gristmill was completed. The mill was not fully functional until 2002 with the rebuilding of the millrace and additions of the internal machinery. Currently, the mill produces and sells flour. Plans are being formulated to rebuild the distillery after archaeological investigations are complete; although spirits will be made, they will not be sold. (WL.)

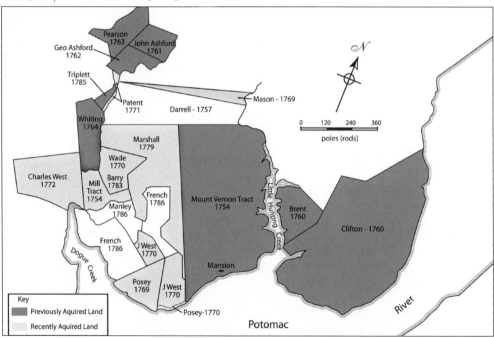

The next several tracts Washington purchased included the ferry landing from Posey as well as farmland from the Marshall, Wade, and West families. The new farmland gave Washington the luxury of growing a diversity of crops as he developed his version of a model farm. Still desiring to purchase the rest of the neck, he began to rent acreage from the French family, one of the last holdouts. (RP.)

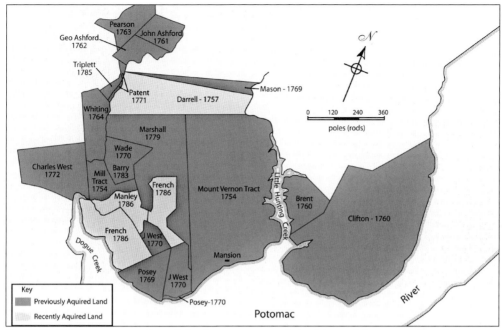

By 1786, Washington purchased the last segments of the Mount Vernon neck and began to realign the field boundaries. He wrote to many well-known agriculturists asking for advice about developing a model farm. (RP.)

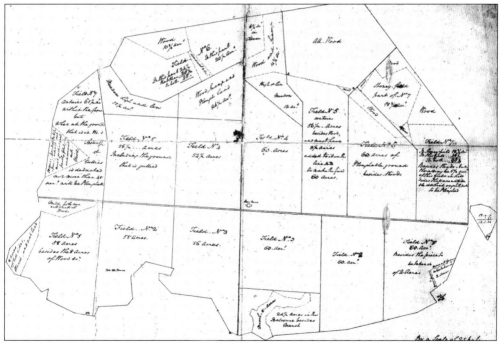

Washington decided the model farm would be located on the acreage bought from the French and Posey families, which he referred to as "Frenches and Ferry Farm," and he drafted this 1788 map of his proposed fence lines and crop rotations. About this time, he wrote to noted British agriculturist Arthur Young about plans for a barn that would accommodate approximately 500 acres. (GM.)

Young supplied plans for a substantial brick barn, shown here, to be two stories high, 100 feet long, and over 100 feet wide, quite a large undertaking for the period. The barn was placed at the end of a wide lane coming down from the north and just north of the road leading from the mill to the ferry landing, and it was described as "equal perhaps to any in America." (GM.)

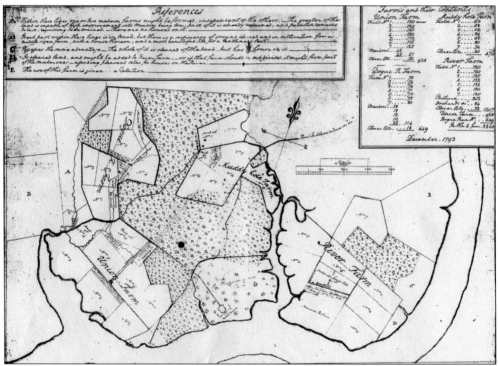

Between 1786 and 1793, Washington continued correspondence with Arthur Young, sending him this map of Mount Vernon showing the crops and buildings and asking him for contacts with people interested in buying or renting the farms. Washington was becoming weary of managing his farms, it seems, but could not stand to see them fall into disrepair. Apparently, there were no takers, and he kept the land. (GM.)

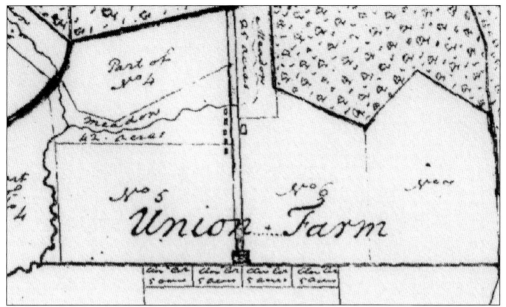

Between 1788 and 1793, Washington developed French's and Ferry Farm into an efficient farm, renaming it Union Farm in January 1793. He built an overseer's house across from where he wanted to align the slave quarters north of the barn on the wide lane, as shown in this 1793 detail. The overseer's house location is now on Fairfax County Park Authority land as part of Grist Mill Park. (GM.)

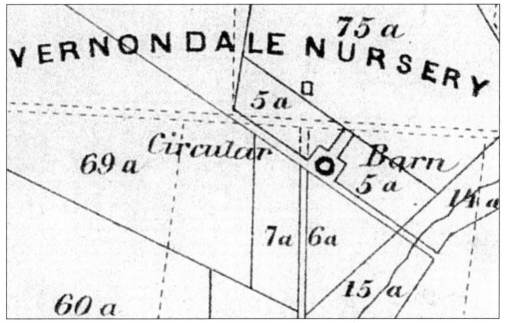

In 1794, Washington designed a large, 16-sided barn for a thresher area on his Dogue Run Farm, shown here on an 1859 map. The barn, standing until the late 19th century, has been reconstructed in the filled-in drainage to the south of Mount Vernon in an area Washington referred to as "Hell hole." The Ladies' Association had the entrance to the wharf dredged to create enough sludge to fill Hellhole. (VR.)

Washington had owned slaves since he was 11 years old when he inherited them from his father's estate at Ferry Farm, near Fredericksburg. The slaves around the manor house had better living conditions than those on the outlying farms. In 1798, Polish traveler Julius Niemcewicz went to Union Farm and stated they "lived in huts, because they cannot go by the name of houses" regarding their poor shape of repair. (PP.)

In 1794, Washington stated that his motive for selling or renting the farms was to provide a tranquil life for himself after leaving office, since his farms were becoming somewhat unproductive. He also mentioned that he wanted to "liberate a certain species of property which I possess," but this did not happen in his lifetime. (PP.)

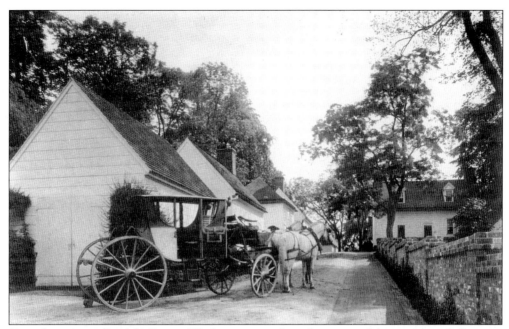

Over the course of his life, George Washington may have been one of the most traveled men in America, logging several thousands of miles. His carriage can still be seen at the mansion, as shown in this 1930s-era photograph. On special occasions, he rode in his formal carriage, but more often than not, he was seen on horseback. (PP.)

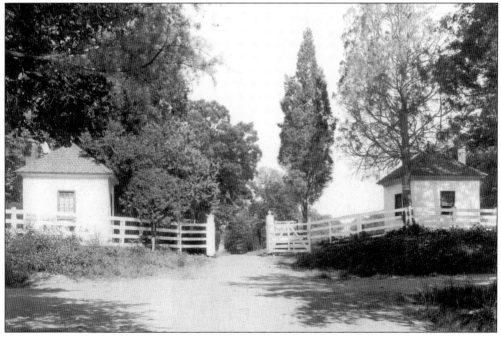

The white gatehouses at the head of the approach to the manor house framed the entrance from the main road to Ferry Landing, as seen here in the 1930s. The gate houses still stand today and are worth the short drive south on the George Washington Memorial Parkway to old Mount Vernon Road and a few hundred yards to the left for a rare look at Mount Vernon. (PP.)

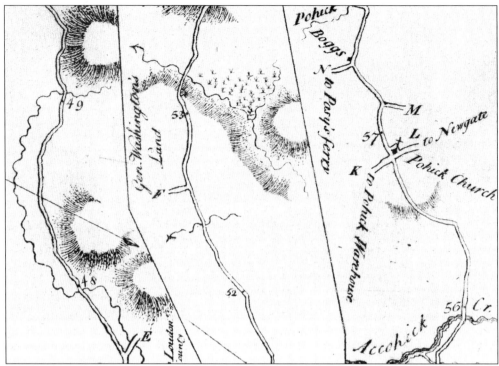

Touted as America's first road atlas, Christopher Colles's 1789 map series of the main road along the Mid-Atlantic States from Albany, New York, to Yorktown, Virginia, ran close to modern Route 1. The atlas showed the road crossing by Mount Vernon on "General Washington's Land." (GM.)

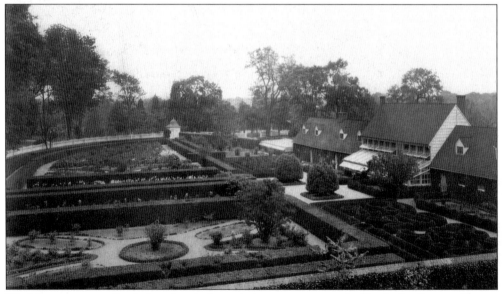

Washington personally designed and planned almost every aspect of both the farm and house areas of Mount Vernon in intricate details, as seen in his diaries, letters, and ledgers. The new garden design was realized in 1783 but fell into disrepair by the mid-19th century. This photograph was taken in the 1930s. (PP.)

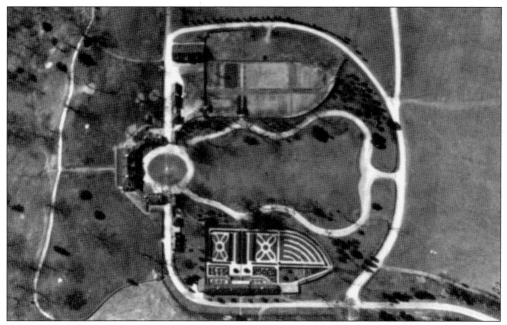

After years of special attention, the Mount Vernon gardens still exist today, closely resembling Washington's original plan. This aerial photograph was taken of the grounds and gardens in the mid-1920s. (NARA.)

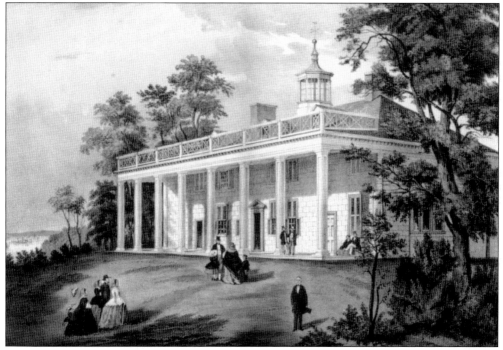

By the end of the American Revolution in 1783, Mount Vernon, the manor, closely resembled its present self and began to take on a personality of its own. As Washington's popularity and exposure to the American public increased, so did the desire of Americans and foreign dignitaries to travel to Mount Vernon to pay their respects. (PP.)

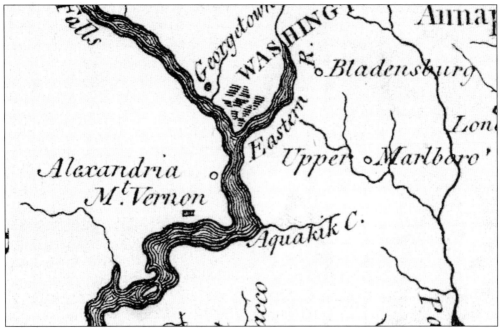

As the Federal city took form in the District of Columbia only 15 miles to the north, the name of Washington denoting his farm was quickly being replaced with "Mt. Vernon," as shown in this 1796 Matthew Carey map detail. Rarely after he was elected President would the location of his home be labeled with just the name of Washington, as was commonly done prior to his election. (GM.)

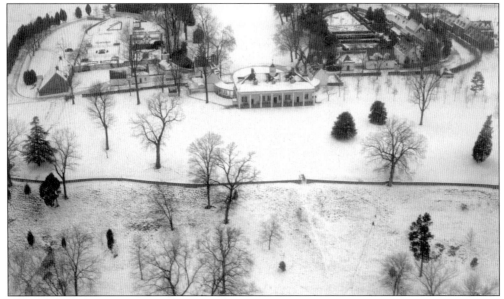

On December 12, 1799, Washington rode across his farms in a snowstorm and by the time he reached home, he was getting sick. Quickly writing a letter to his overseer complaining of the livestock conditions at Union Farm, Washington retired upstairs to his bed. This would be his last letter. The next day, he became increasingly sick and was treated by his physicians. This winter scene was taken in 1926. (NARA.)

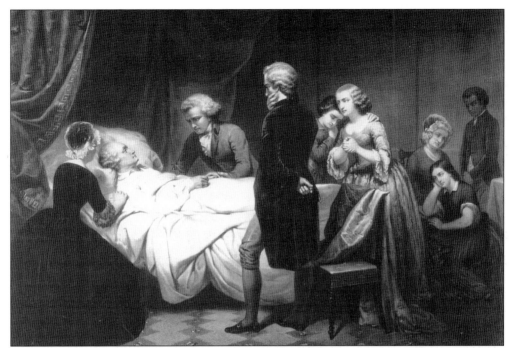

His condition worsened and by the evening of December 14, he was failing. After several bleedings and medicinal administrations, George Washington died at the age of 67 years in his beloved Mount Vernon with his wife of 40 years in the room with him. (PP.)

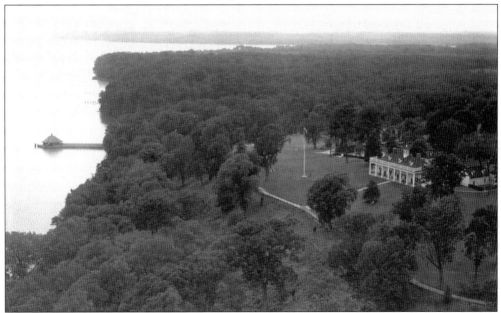

Washington's death was mourned by the whole nation. His slaves were released through his will, something he could not bring himself to do during his lifetime. Martha lived only a few years, dying in 1801, and her slaves were also emancipated. The entire estate went to his nephew, Bushrod Washington, in the Washington family, where it would remain long enough to be saved by preservationists. (NARA.)

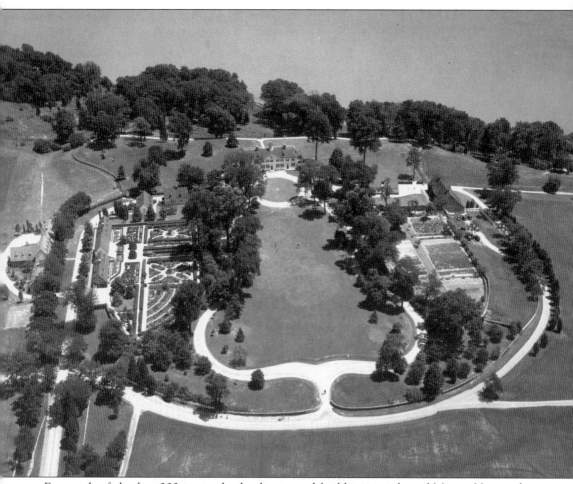

For much of the last 200 years, the landscape and building complex of Mount Vernon has retained its 1799 visage, particularly with hard work and dedication from the Mount Vernon Ladies' Association. The selling of much of his estate would see change in the surrounding landscape, but most of the mansion farm containing Mount Vernon was always kept intact, as shown here in this 1920s aerial photograph. (NARA.)

Two

GEORGE WASHINGTON'S CLOSE NEIGHBORS

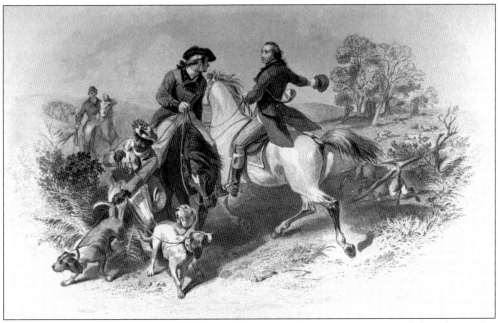

George William Fairfax and George Washington are shown as two good friends in this depiction of a fanciful fox hunt in the countryside. This chapter will explore the brotherly relationship between George Washington and the Fairfax family, his neighbors on the neck just down river from Mount Vernon. George Mason and his home at Gunston Hall will also be discussed with his impact on Washington's political life. (PP.)

Thomas, the sixth Lord Fairfax and a descendant of the Culpeper family, inherited the Virginia Proprietary, which contained most of northern Virginia, in the 1730s. At first, he was ambivalent about the project but later became the first Fairfax to travel to Virginia to personally handle the land distribution. Thomas never married, dying in 1781 at the ripe old age of 88 years. (FB.)

William Fairfax, Thomas's cousin, was summoned to Virginia in 1734 to assume the role of Customs Officer of the southern Potomac and Proprietary agent. He bought over 2,000 acres and built one of the largest brick mansions in northern Virginia in 1740, named "Belvoir," or "beautiful to see," shown in this artist's depiction. The manor supposedly resembled Writhington near Bath, England, where William's son George William Fairfax later resided. (FB.)

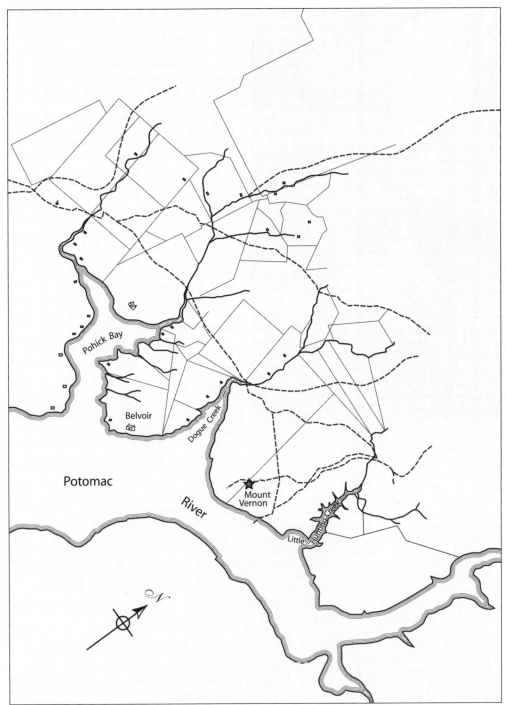

This map was modified from an original map drafted by George Washington in 1768. While the actual intent is not known, Washington may have been trying to record the neighboring tracts of land within a few miles of Mount Vernon. The portion on Dogue Creek was not finished on the original, but it does illustrate the tracts of land on Belvoir Neck that William Fairfax had to buy to create Belvoir. (RP.)

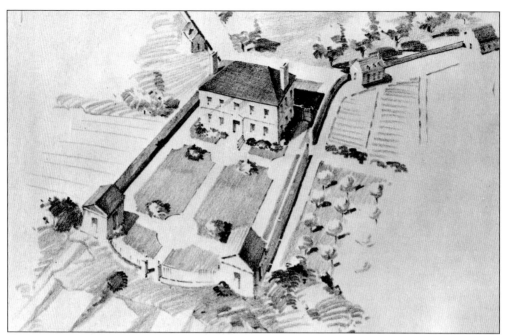

Overlooking the Potomac River, Belvoir was an imposing site for travelers along the river looking up the bluff to the manor. It was prominently placed above the river with a beautiful garden situated between the bluff edge and the manor. Two small gatehouses bordered the garden on the riverside of the manor and an orchard was to the side of the garden area. (FB.)

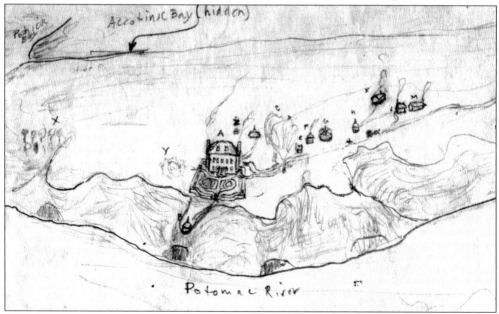

In this sketch by a Fort Humphreys engineer in the 1920s, the relationship of the manor house and outbuildings with the bluff and the Potomac River is seen. The kitchen, slave quarters, and other outbuildings lined the carriage entrance from the main road through the central portion of the neck. The Fairfax cemetery, where William and his third wife were buried, was only a few hundred feet from the manor. (FB.)

George William Fairfax, William's son, inherited Belvoir after his father's death in 1757. He frequently entertained at Belvoir, served in the House of Burgesses, and became one of George Washington's closest friends. He sailed to England in 1773 for a visit just before the American Revolution broke out, making many assume he was a Loyalist, but in reality, he had returned to settle an estate and died there in 1787. (FB.)

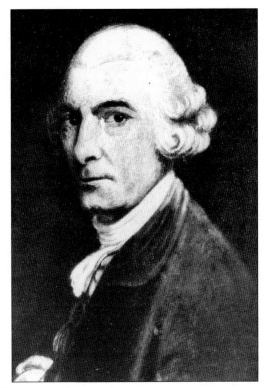

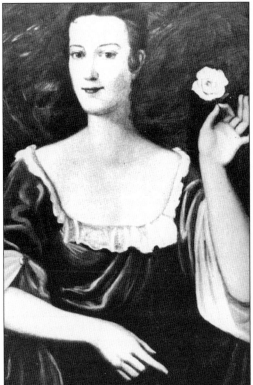

George William Fairfax married Sally Cary, and his sister Anne Fairfax married Lawrence Washington, George's older half-brother. Many historians comment on the relationship between Sally Cary and George Washington, drawing conclusions from their early correspondence. Amid much speculation, suffice it to say they became lifelong friends. One example of the friendship is highlighted in a 1785 letter in which Washington said the happiest moments of his life were spent at Belvoir. (FB.)

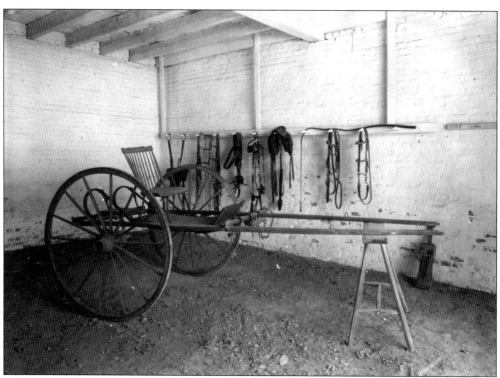

JNE 2, 1774.

THE

NUMBER 1182.

VIRGINIA GAZETTE.

With the freshest ADVICES, FOREIGN and DOMESTICK.

CIVITATE LIBERA LINGUAM MENTEMQUE LIBERAS ESSE DEBERE.——*Suet.* in *Tib.* 3. 28.

Printed by *ALEX. PURDIE, and JOHN DIXON,* at the POST OFFICE.

To be SOLD at Belvoir, the Seat of the Honourable
George William Fairfax, Esq; in Fairfax County,
on Monday the 15th of August next (pursuant to
his Direction)

ALL his HOUSEHOLD and KITCHEN FURNITURE of every
Kind, consisting of Beds and their Furniture, Tables, Chairs, and
every other necessary Article, mostly new, and very elegant.——Ready
Money will be expected from every Purchaser under 5 l. and twelve
Months Credit allowed those who exceed that Sum, upon their giving
Bond and approved Security, to carry Interest from the Date, if the
Money is not paid within forty Days after it becomes due.
(6) FRANCIS WILLIS, Junior.

To be RENTED, from Year to Year, or for a Term
of Years,

BELVOIR, the beautiful Seat of the Honourable *George William Fair-
fax,* Esq; lying upon *Potowmack* River in *Fairfax* County, about
fourteen Miles below *Alexandria.* The Mansion House is of Brick, two
Stories high, with four convenient Rooms and a large Passage on the lower
Floor, five Rooms and a Passage on the second, and a Servants Hall
and Cellars below, convenient Offices, Stables, and Coach House ad-
joining, as also a large and well furnished Garden, stored with a great
Variety of valuable Fruits, in good Order. Appertaining to the Tract
on which these Houses stand, and which contains near 2000 Acres (sur-
rounded in a Manner by navigable Water) are several valuable Fisheries,
and a good Deal of cleared Land in different Parts, which may be let
altogether, or separately, as shall be found most convenient. The Terms
may be known of Colonel *Washington,* who lives near the Premises, or of
me in *Berkeley* County.
(tf) FRANCIS WILLIS, Junior.

The Fairfax riding chair, one of the few surviving artifacts from the George William and Sally Fairfax collection, remains at Mount Vernon. Washington purchased several items from their estate sale in 1784, but the majority of the items were sold off to unknown parties. (MV.)

George William and Sally Fairfax sailed to England in 1773 to settle an estate, selling most of the furnishings and renting out the Belvoir property, as shown in this 1774 advertisement. The American Revolution came and went, and while the Fairfaxes were still abroad, Belvoir burned in a terrible fire in 1784. George Washington wrote to them a few weeks after the fire, "Belvoir is no more." (FB.)

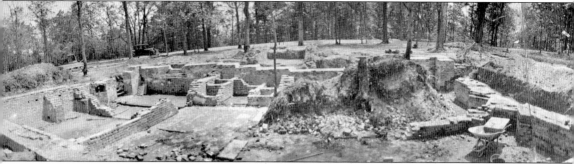

The charred walls of Belvoir stood above the Potomac for 30 years until being felled by British cannon fire in September 1814. The foundation was rediscovered in 1890 by historians and excavated in 1919, 1931, and the 1970s by the Army Corp of Engineers and archaeology students. Today, the remains of Belvoir rest under a canopy of majestic trees along a picturesque historic walking trail on Fort Belvoir. (FB.)

The fireback from the Belvoir fireplace was retrieved from the rubble during the 19th century and was in local hands for many years. The owners made a cast of the fireback and sold large and small versions to the public. The original fireback was donated to the Army Corps of Engineers and now hangs above the fireplace in the Officers Club in Mackenzie Hall at Fort Belvoir. (FB.)

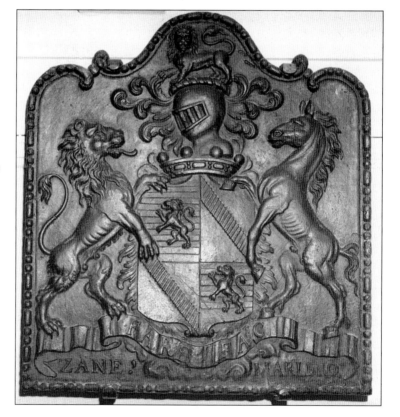

Bryan Fairfax, George William's brother, lived at Belvoir in his youth and reluctantly became the eighth Lord Fairfax and went to England. He returned to Virginia where he became a minister and a dear friend of George Washington. Many letters exchanged between the two men have been published demonstrating a close relationship. Archival records suggest that Washington may have named Bryan's house Mount Eagle, near Alexandria in 1790. (FB.)

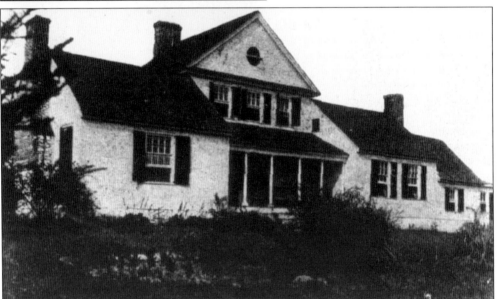

George Washington dined with Bryan Fairfax at Mount Eagle on December 7, 1799, his last dinner away from Mount Vernon. Washington then reciprocated by hosting Bryan at Mount Vernon on December 10, his last formal guest before Washington died on December 14. Bryan and his son Ferdinando were pallbearers for Washington. Mount Eagle, shown here in the 1960s, was razed in 1968. (VR.)

Ferdinando Fairfax, Bryan's son, inherited Belvoir in the 1790s. As the surviving founding investor in Anthony Fitch's steamboat company, he declared himself the rightful owner of the steamboat patent instead of competitor Robert Fulton's widow in 1815, but Fulton's widow won the case. Ferdinando was also the godson of George and Martha Washington. He was present at the laying of the Federal Capitol cornerstone and was one of the pallbearers at Washington's funeral. (FB.)

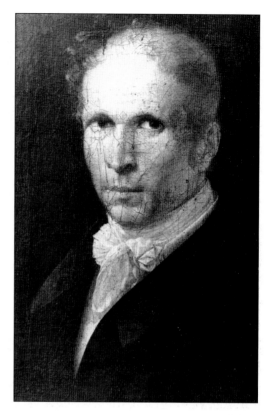

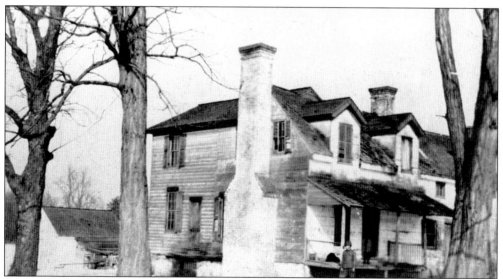

Ferdinando may have built this house on Belvoir neck for his wife and 16 children, shown here in 1918. He sold the Belvoir property in trust to Lawrence Lewis, husband of George Washington's adopted granddaughter Nellie before moving to Mount Eagle. Overseer Levi Burke lived in the house for the next 40 years. Dying in 1820, Ferdinando had relinquished the Belvoir tract to William Herbert Jr., ending 100 years of Fairfax ownership. (FB.)

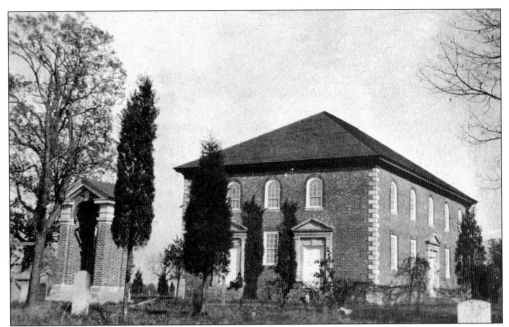

George Washington and many of his neighbors attended Pohick Church, which first held services in 1774, shown here in 1918. Both Union and Confederate troops occupied the building during the Civil War, destroying much of its interior. Now, fully renovated, the church pews have plaques showing where the Washington and Mason families and other members sat, and the site is definitely worth a visit. (FB.)

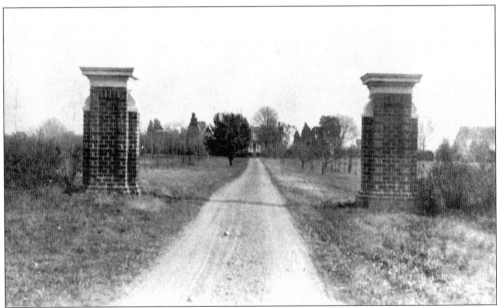

George Mason, the author of the Virginia Bill of Rights and signer of the Declaration of Independence, lived for most of his adult life on Mason's Neck, two necks downriver on the Potomac from Mount Vernon. While they were neighbors and friends, George Washington appears to have rarely visited Mason's home, called Gunston Hall. (FB.)

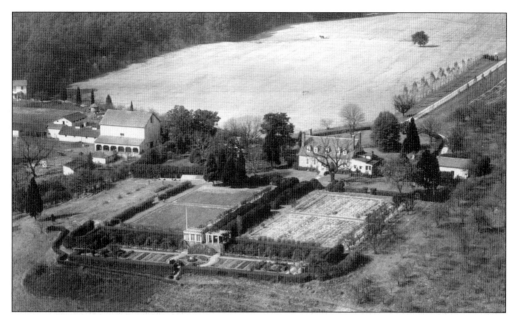

Facing Accotink Bay rather than fronting the actual Potomac River, Gunston Hall was nonetheless still an imposing view from the water coming down the main channel from the north. Surrounding by thick woods and fertile farmland, as shown in this 1926 photograph, George Mason IV built his brick home about 1758. (NARA.)

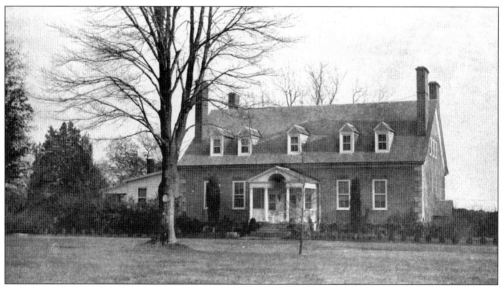

Louis Hertle bought the property in 1911 and spent almost 38 years restoring Gunston Hall closer to its former glory. Hertle discussed with President Franklin Roosevelt the history of the area, including Belvoir and the Fairfax family, giving Roosevelt the idea to change the name of Fort Humphreys to Fort Belvoir in 1935. (FB.)

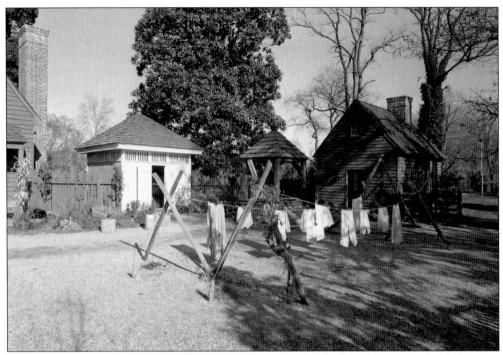

The dairy and kitchen areas outside the main house at Gunston Hall show a typical day on a colonial plantation, shown here in the 1970s. (PP.)

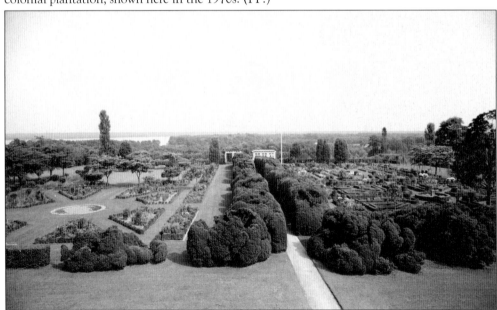

Typical of most large plantations of the period, Gunston Hall had, and still has, a beautiful garden. Today many of the original boxwoods have survived an early 20th-century interpretation that masked some of the original design. Archaeologists are investigating the garden area to try and recreate Mason's original configuration. Owned by the Commonwealth of Virginia and operated by the Colonial Dames, Gunston Hall is open to visitors year round. (PP.)

Three
Distribution of Mount Vernon Land and the Coming of the Quakers

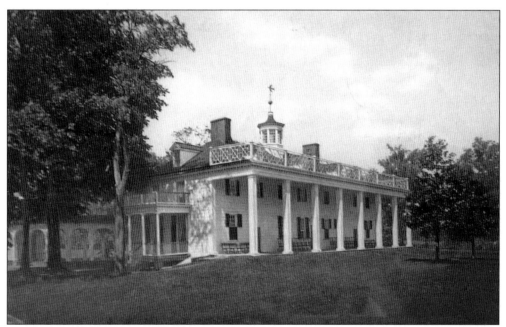

Upon Bushrod Washington's death in 1829, the mansion farm went to John Augustine Washington II, after whose death in 1832 it was left to his wife Jane. Their son, John Augustine Washington III, then received Mount Vernon. At this time, Mount Vernon, falling into disrepair, was now in the hands of an owner willing to sell the property to someone for future preservation. This postcard of Mount Vernon was printed in 1899. (VR.)

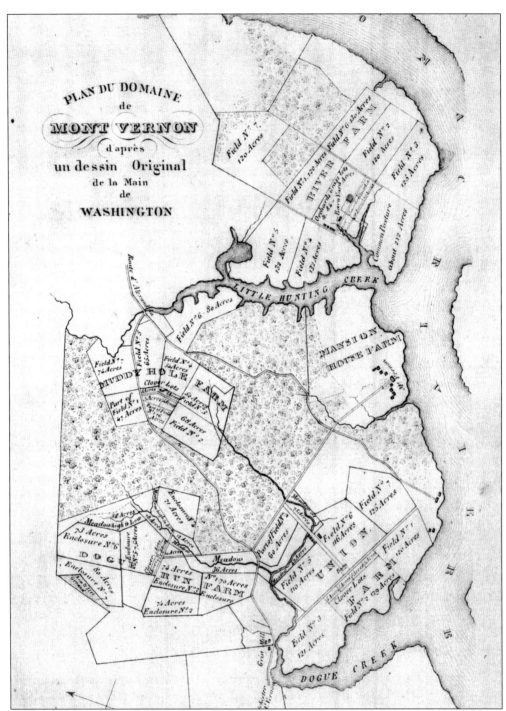

This 1840 French map of George Washington's estate at Mount Vernon illustrates the five farms he developed around the mansion house. By his will, the Mansion, Muddy Hole, and Union Farms went to his nephew Bushrod Washington, Dogue Run Farm went to his step-granddaughter Nellie Custis Lewis, and River Farm went to two great-nephews, George Fayette Washington and his brother Charles Augustine Washington. (GM.)

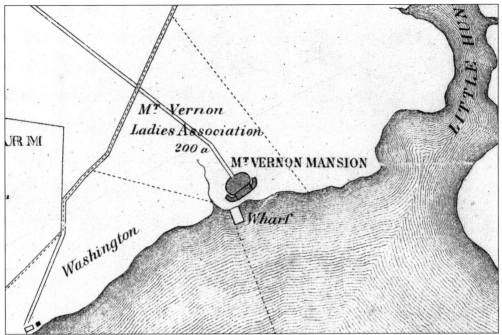

The Mount Vernon Ladies' Association, founded by Miss Pamela Cunningham, saved Mount Vernon from deterioration by purchasing 200 acres from John Augustine Washington III in 1859 for $200,000. Shown here on an 1859 map by Quaker neighbor W. Gillingham, the Ladies' Association bought the mansion, wharf, main entrance, gatehouses, and the drainage southwest of the house Washington called Hellhole. See chapter six for more on tourism at Mount Vernon. (GM.)

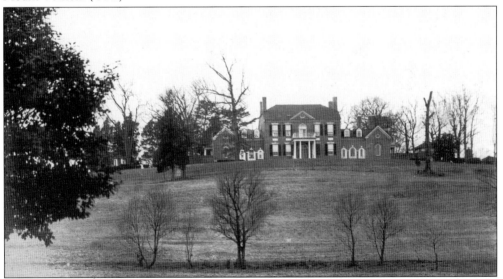

Woodlawn was built on land given by George Washington from his Dogue Run Farm to his step-granddaughter Nellie Custis when she married his nephew Maj. Lawrence Lewis in February 1799, 10 months before Washington died. The estate was on a prominent hill that could see Mount Vernon in the distance to the east from the riverfront side, as shown in this 1918 photograph from Route 1. (FB.)

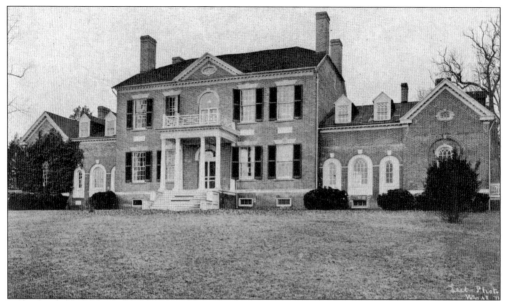

Close Washington friend Dr. William Thornton, who designed two townhouses for Washington next to the U.S. Capitol, was chosen by the Lewises to plan Woodlawn. The Lewis family stayed at Woodlawn until 1846, when the estate was sold to Quakers from Burlington County, New Jersey, who would own the house for only seven years. Woodlawn is shown here in 1918. (VR.)

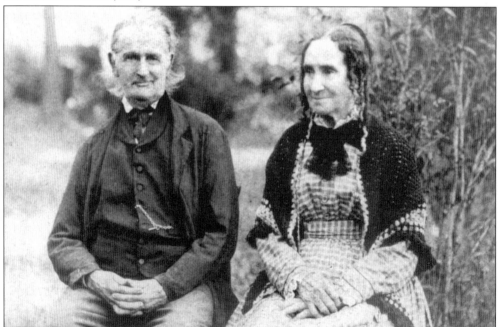

John and Rachel Mason, shown here in the 1880s, bought Woodlawn from Quaker Paul Hillman Troth in 1853. They would own the estate for almost 35 years. Mason was a descendant of Capt. John Mason of New Hampshire and his wife, the former Rachel Lincoln, was from Massachusetts. He also helped found the Woodlawn Baptist Church across Route 1 where he and Rachel were buried. (WL.)

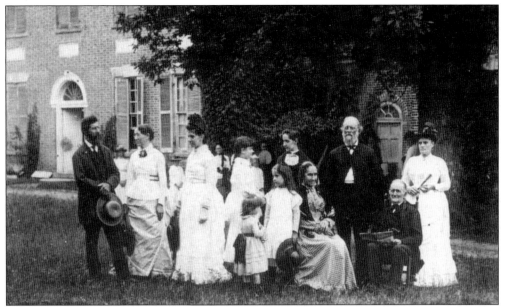

During 35 years at Woodlawn, the John Mason family held many weddings and other social events at the estate, as shown in this photograph at Woodlawn in the 1880s. John died in 1888 at the age of 90, and Rachel died the following spring. Their children had been given various portions of the Woodlawn tract and the remaining 45 acres and mansion house were sold in 1892. (WL.)

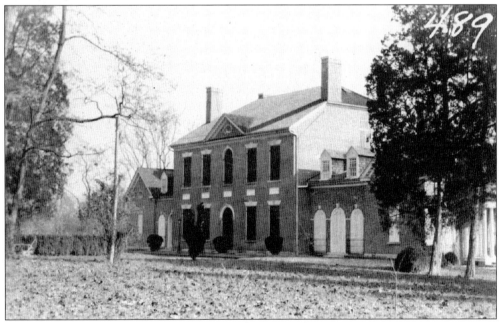

The New Alexandria Land and River Improvement Company bought Woodlawn in 1892 as a terminus station for the electric trolley line from Alexandria, discussed in chapter six. Paul Kester, successful playwright, and his novelist brother Vaughn, bought the house and partially restored the home, raising the hyphens and wings, shown here in 1918. Today, the site is under the jurisdiction of the National Trust for Historic Preservation. (FB.)

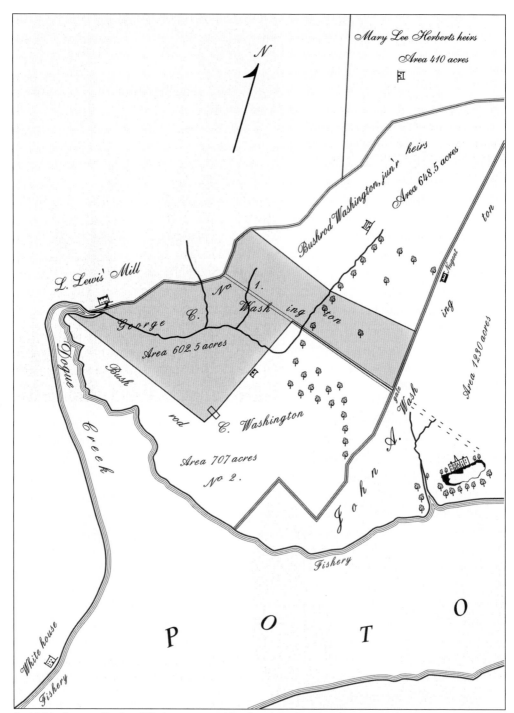

Mary Lee Herberts heirs
Area 410 acres

Bushrod Washington, jun'r heirs
Area 648.5 acres

L. Lewis' Mill

No 1.

George C. Washington
Area 602.5 acres

C. Washington
Area 707 acres
No 2.

Dogue Creek

Bush rod

White house
Fishery

Fishery

John A. Wash ... ton
Area 1230 acres

P O T O

In 1831, George Corbin Washington and Bushrod Corbin Washington split Union Farm down the wide lane to the 1788 brick barn, dividing the barn in half! Samuel Whitall, a New Jersey Quaker and next-door neighbor to George Corbin Washington in Georgetown, D.C., bought both halves of the tract to get full use of the barn. Whitall sold Union Farm lots to other Quaker families, including the Waltons and Ballingers. (RP.)

Lucas Gillingham and Thomas Wright, Quakers from Burlington County, New Jersey, traveled to Virginia looking for timber tracts to use for shipbuilding in 1846 and found Woodlawn for sale. Contacting the firm of Troth-Gillingham and Company back home, they arranged for Chalkley Gillingham (shown here) and Jacob Troth to buy Woodlawn and 2,030 acres of land in October 1846. (WMH.)

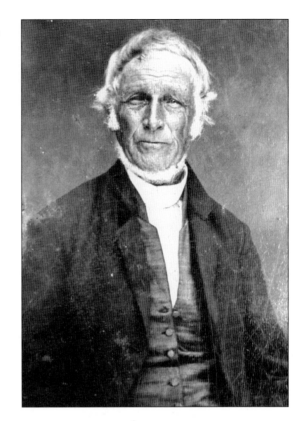

Chalkley Gillingham's wife, shown at left, was formerly Miss Kezia Warrington, granddaughter of John Thompson of Philadelphia, a friend of George Washington. During the Civil War, many of the young men from the Quaker community around Woodlawn joined the military; however, many moved north across the Potomac River and back to New Jersey for the duration. (WL.)

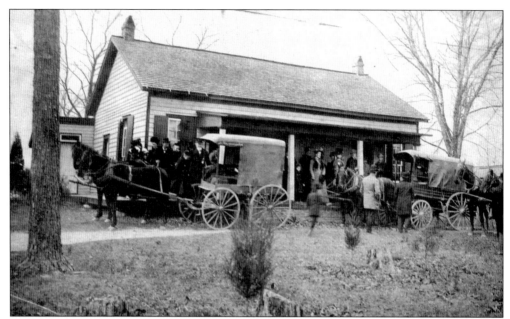

The Friends Meeting House was built on a one-acre lot given for that purpose by Chalkley Gillingham in 1853. The first section was quickly enlarged, as shown in this 1898 photograph, because of the rising number in the regular congregation as well as non-member attendance. A carriage house was built behind the meeting house. The meeting house has been restored and is now nestled between Fort Belvoir and Woodlawn. (WMH.)

The historic Woodlawn Friends Meeting House is also the final resting place for many of the Quaker community that has flourished near Mount Vernon for over 150 years. The peaceful setting of the Friends cemetery is located just behind and within a few feet of the Meeting House. (PO.)

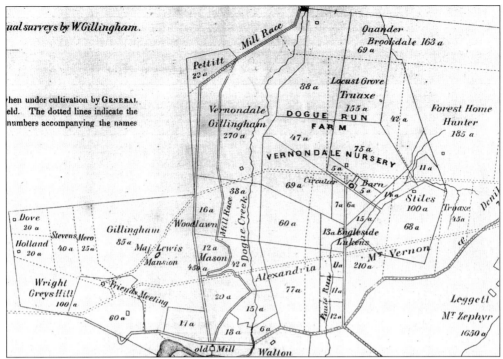

In 1859, Chalkley Gillingham's Vernondale and his nursery were drafted where George Washington's circular barn was located. The Quakers also befriended the African-American community around Gum Springs, many of whom were former Mount Vernon slaves, by hiring them not only as laborers but also by selling them land, like the Quanders, shown at the top right. (GM.)

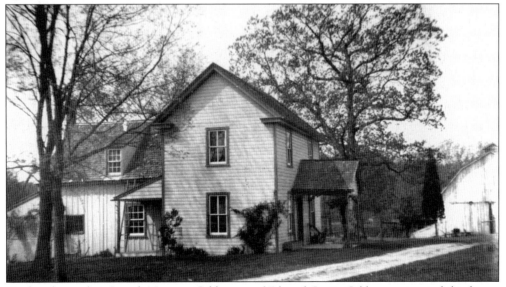

Quaker descendent Joseph Norman Gibbs, son of Edward Curtis Gibbs, constructed this house about one mile from Mount Vernon, shown in the late 1800s. More commonly seen in print as J.N. Gibbs, he founded the first lunch counter outside the gates at Mount Vernon and is discussed later in chapter six. (JGL.)

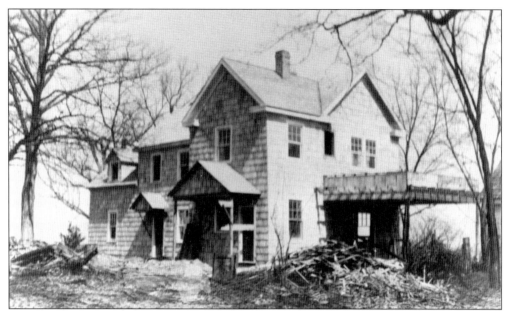

Edward Curtis Gibbs built this house off of Mount Vernon Road in 1869 after living at Little Hollin Hall since 1852. Born in Burlington County, New Jersey and once a member of the Friends Meeting House at Woodlawn, he left the congregation when he did not ask permission of the Friends to marry his wife. The house is shown here in 1924 during a remodeling phase. (JGL.)

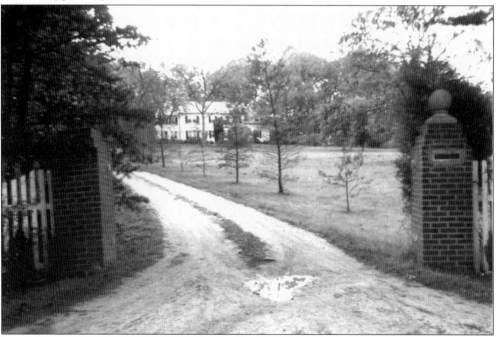

The Edward Curtis Gibbs house is shown here in the 1950s, several owners later. Many of the small farms and residences that were built in the late 19th and early 20th century around Mount Vernon had similar gates to give the appearance of a sizable estate and class status. The Gibbs house still stands today, but has been enveloped by a housing division. (FJS.)

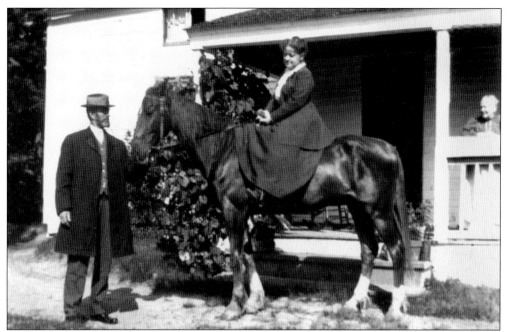

An unidentified woman is on horseback at the Edward Curtis Gibbs "homeplace" near Mount Vernon in this late 19th-century photograph. Charles Edward Gibbs is holding the horse and the woman on the porch is not identified. (JGL.)

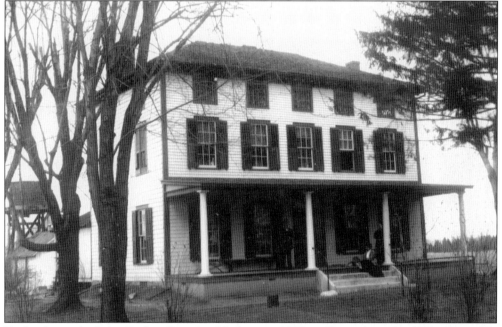

Engleside was built by Quaker Courtland Lukens in 1859 on Route 1 north of Woodlawn. He came from Montgomery County, Pennsylvania, across the river from Burlington County, New Jersey, where most of his new neighbors were from. This photograph of Engleside was taken in 1915 by J. Harry Shannon, who was locally known as "the Rambler." The house was razed many years ago. (VR.)

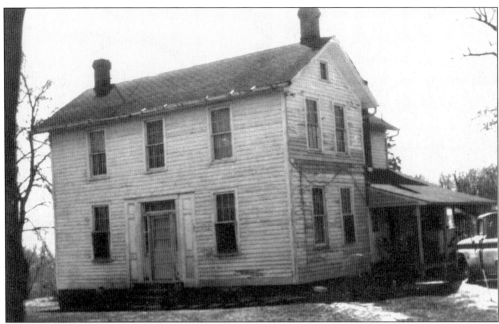

Grand View, located next to Woodlawn, was home to Quaker Jacob M. Troth and wife Ann Walton. In 1878, one of the most remarkable events of the Woodlawn area took place at Grand View. President Rutherford B. Hayes and his wife Lucy, who were visiting Mount Vernon, came to Woodlawn at the request of John Mason, Woodlawn's owner and Troth's neighbor. (FCPC.)

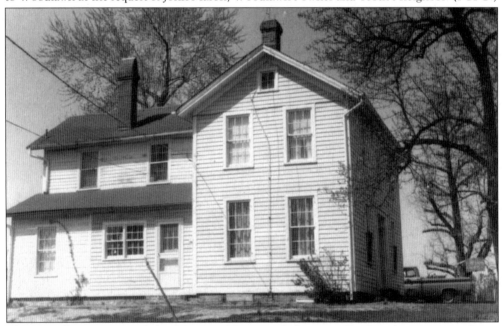

The Friends came out of the Meeting House and, hearing the President was nearby at Woodlawn, assembled at Grand View. The President, touched to hear of the gathering next door, walked across the lawn to Grand View and greeted each person present, admiring the antique furniture the Troths had brought from New Jersey; some items were already over 150 years old. (VR.)

Sherwood Hall was built by Quaker Charles Ballinger, brother of John Ballinger. John built nearby Union Farm in 1857. Charles's wife Maria Gibbs was the sister of Joseph Norman Gibbs and Charles Gibbs. The Woodlawn Farmers Club had an annual dinner each April at Sherwood Hall where sometimes as many as 100 people would be served dinner. (VR.)

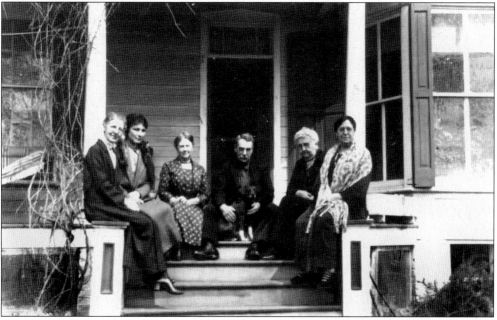

This porch scene took place at Sherwood Hall on an unknown date with, from left to right, unidentified, Louise Gibbs (wife of Edward C. Gibbs II), Alice Wilkinson, Frank Wilkinson, and two unidentified. Sherwood Hall was a dairy for many years, selling milk to the local communities. The old Accotink Pike section from Route 1 to Fort Hunt Road is now called Sherwood Hall Road. (JGL.)

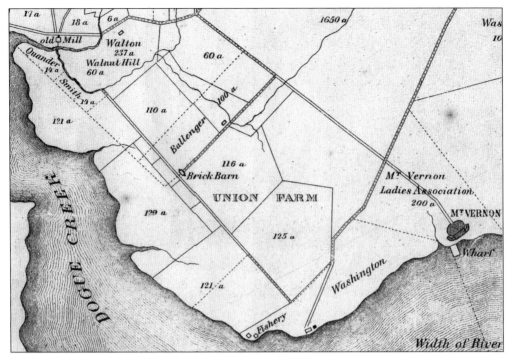

This 1859 map illustrates both Union Farm and Mount Vernon. The brick barn is the 1788 barn built by George Washington, and modern Ferry Landing Road runs next to the barn to the south. In 1857, Quaker John Ballinger and his wife Rebecca Walton, daughter of David Walton, moved into a newly constructed house named after Union Farm. Two African-American families, the Quanders and Smiths, lived across the creek from the Grist Mill. (GM.)

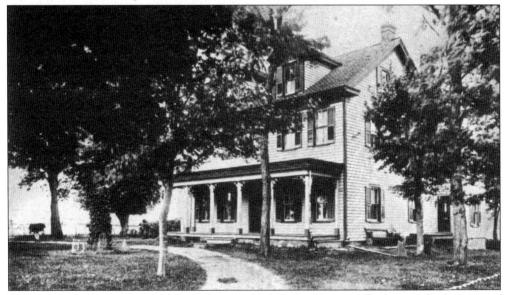

The two-and-a-half-story wood frame house called Union Farm was built near the location of where Washington aligned his slave quarters in 1793–1794 on Union Farm. The house would have been one of the first houses on the left after a traveler left the gates of Mount Vernon on Old Mill Road, even though it is almost one mile from the gatehouses. (FCPC.)

Legend has it that the basement of Union Farm House was the basement of the old overseer's house Washington had built in 1793–1794, which is in error. Archaeological evidence has shown the overseer's house was across the lane from where Ballinger built his house. It is possible that Ballinger, also owning the overseer's house property at the time he built Union Farm, might have incorporated materials from the older house. (FCPC.)

Union Farm stayed in the Ballinger family until after 1900. One of the subsequent owners was Sen. Moses Clapp and his daughter, Virginia. In 1918, the tract was bisected by the Mount Vernon–Camp Humphreys Electric Railway corridor, which still forms the northwest boundary of the property. The house is currently surrounded by the Mount Vernon Country Club and the Grist Mill Park ball fields. (FCPC.)

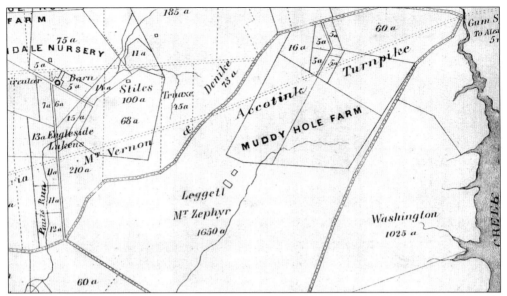

Aaron Leggett, a single New York businessman, bought much of the Union and Muddy Hole Farms from Samuel Whitall in 1848. Leggett lost a ship in Mexico in 1830 and received monies from the Mexican government as reparations in 1848, probably using that money to buy the farms. Mount Zephyr was located in the central portion of Muddy Hole Farm, as shown in this 1859 map. The Friends had built a new road between Accotink and Gum Springs, called the Mount Vernon and Accotink Turnpike, later turned over to Fairfax County. (GM.)

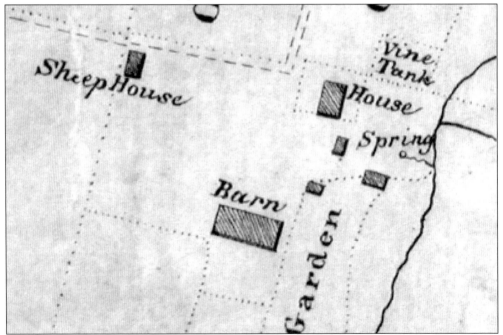

In 1856, Leggett wanted to sell the estate and personally hand drafted a map of the land he owned, stating that the land was "high and elevated with a view of several miles down the Potomac, affording beautiful sites for Country residences." He was not able to get the land sold quickly and by the time he died in 1860, the estate was still intact. (WMH.)

This sale bill from 1860 illustrates the Mount Zephyr and Union Farm land owned by Aaron Leggett, which surrounded land owned by David Walton and John Ballinger to the left of tracts six and four. North of Lot Eight were three African-American families, the Quanders, Hollands, and Smiths. The son of a German immigrant, John Henry Kuehling, would purchase Lot Four in 1865. (WMH.)

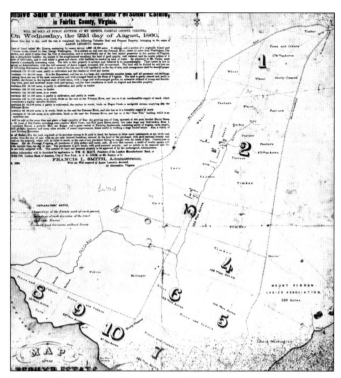

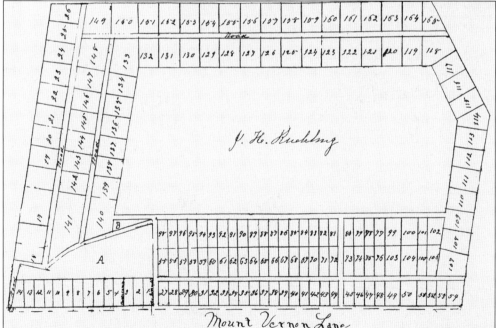

John Henry Kuehling had always said he was saving his money to buy George Washington's farm when he grew up. In 1860, he purchased Lot Four from the Aaron Leggett estate. Kuehling plotted dozens of house lots for a little subdivision in the late 1870s, as shown here, years before any real development occurred in the surrounding area. By the early 1920s, he and his wife had only sold 15 lots. (FCA.)

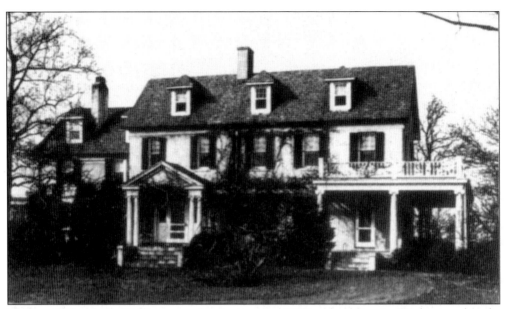

William Clifton built Wellington on his farm around 1740 on land George Washington bought from him in 1760, calling it River Farm. The house, photographed here from a glass plate negative in 1915, was quite large and housed many families over the years. (VR.)

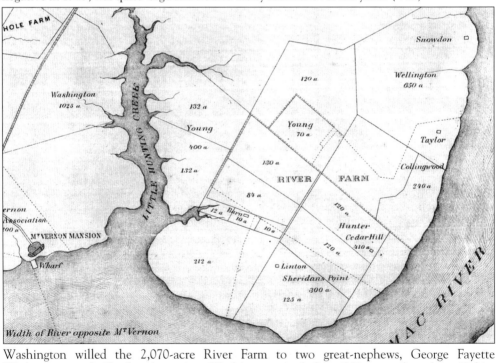

Washington willed the 2,070-acre River Farm to two great-nephews, George Fayette Washington and Charles Augustine Washington, including 360 acres leased to Tobias Lear. The nephews' sister Anna Maria would later get one-third of the farm from her brothers, giving it to her son, Churchill Jones Thornton. Quaker Stacy Snowden purchased over 600 acres from Charles in 1859 and sold the "Wellington" portion to a northern syndicate that went bust. (GM.)

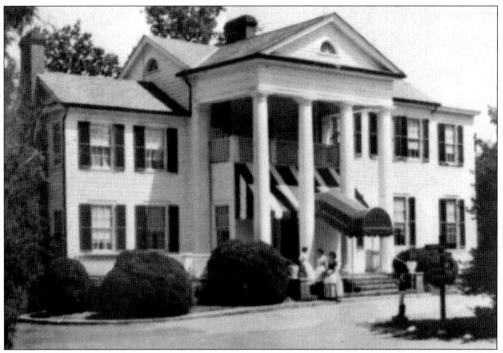

Near Wellington, Quaker Stacy Snowden constructed his new house, which he in turn called Collingwood, named for his New Jersey hometown. Collingwood, home of the National Library and Museum on Americanism, is the site for many formal weddings and social events, well known for the region along the Potomac River. (VR.)

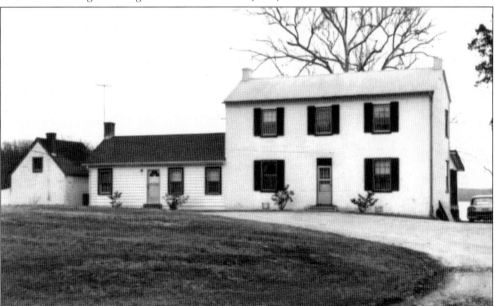

Capt. William Neitzey bought 150 acres from John Augustine Washington III out of the Mansion Farm, which included the old ferry landing. The old Posey house was gone by the 1850s and Neitzey floated bricks from the old district jail in Alexandria down to the landing on his fishing boats to built his house, known as Ferry Landing, shown here in the 1970s. (FCPC.)

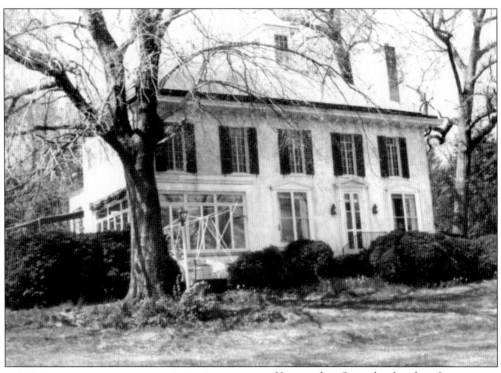

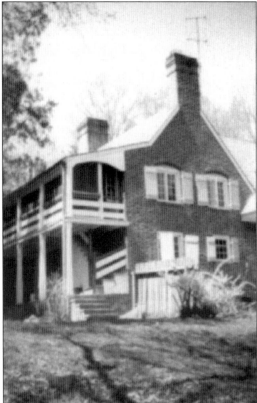

Yet another Snowden brother, Isaac Snowden, built nearby Riverview. Andalusia, shown here in the 1980s, was constructed on River Farm by another brother, William H. Snowden. "Captain" William was a poet and historian as well as a farmer. He established an official post office in his home in 1893, which he romantically called "Arcturus" after a star. (VR.)

To capitalize on the coming electric trolley from Alexandria to Mount Vernon in 1892, William Snowden subdivided his land into seven tracts, calling the hamlet "Arcturus." This photograph is thought to be the cottage Captain William built at Arcturus after he sold Andalusia, shown here in the 1970s. By 1860, most of the Mount Vernon Estate had passed out of Washington family hands into those of other farmers and small developers. (VR.)

Four

MOUNT VERNON AND THE MILITARY

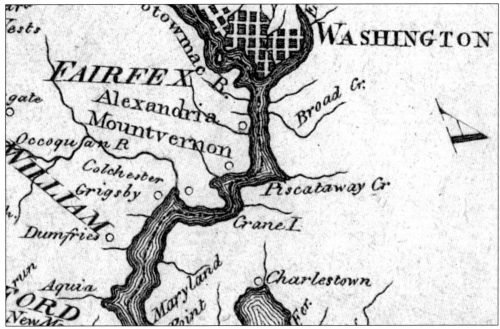

George Washington first suggested batteries to be constructed near Mount Vernon to stop traffic on the Potomac River in late 1775 next to Belvoir Manor on the bluffs above the river. He warned, however, the batteries could not be built without Col. George William Fairfax's approval since it would ultimately spell the end of the house if fired upon, but he was living in England at the time. The British did not harass the upper Potomac River and the batteries were never built during the American Revolution, as shown on this 1796 map. (DR.)

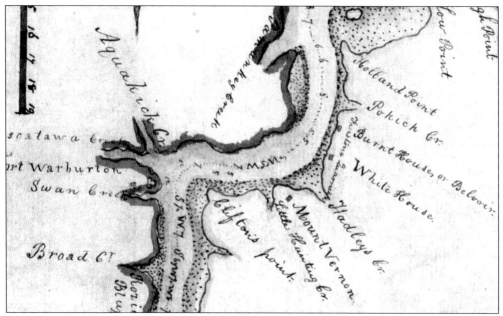

In 1813, William Tatham traversed the Potomac River to find the strengths and weaknesses of the defenses of Washington, D.C. In a detailed report, he discussed having met with Ferdinando Fairfax, owner of the burned Belvoir ruins and White House Landing near Mount Vernon, who stated the military could use his freestone quarries and other materials in their cause. Batteries placed near Belvoir Manor could easily take out enemy ships. (GM.)

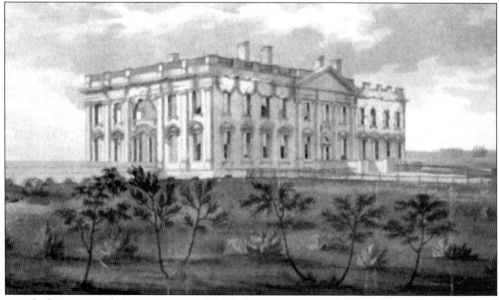

British forces routed the American ground forces at Bladensburg and burned the national capitol in mid-August 1814 after marching overland from the Pataxent River. As shown here, the President's house was burned and would later be painted white to cover up the fire scars, only then being called the White House. (PP.)

60

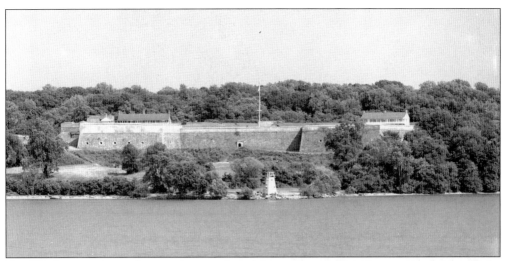

Fort Washington, located across the river from Mount Vernon, was blown up in the face of the advancing ships sailing upriver to relieve British troops in Alexandria after the burning of Washington in August 1814. Located on a high bluff over the Potomac, the deep channel of the river turned to a straight line for the fort, forcing an enemy ship to turn in mid-channel to fire broadside. (PP.)

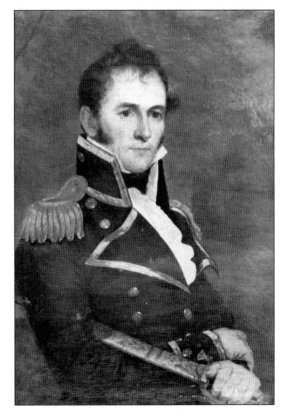

Commodore David Porter, father of Admiral David Dixon Porter of Civil War fame, was summoned to stop the British ships from retreating down the river from Alexandria. Accompanied by Commodores Oliver Perry and John Rodgers, the men led forces down to White House Landing where they quickly set up batteries both on the river's edge and on the bluffs just below the burnt hull of Belvoir Manor. (FB.)

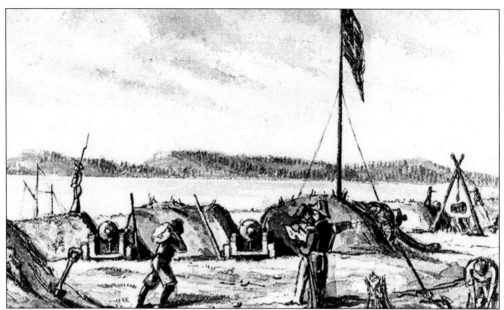

The two forces were engaged for almost four days, with few casualties on either side. Finally, a good wind came and the British ships opened up on the bluffs, having cut out portholes to raise the cannons and tilt the ships to get elevation for their cannons. After passing White House Landing, the British sailed to Baltimore to fire upon Fort McHenry, near where Francis Scott Key was being detained. (FB.)

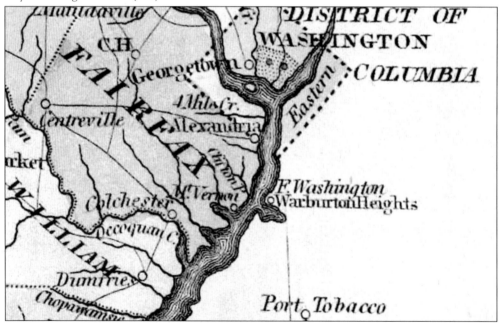

Pierre L'Enfant, the famed architect of Washington, D.C., was asked to redesign Fort Washington just after the War of 1812. The fort was the only major fortification for Washington at the onset of the Civil War and was reinforced when the Ring of Forts was built encircling the federal capitol. Today, the fort is part of the National Park System and open to the public. (GM.)

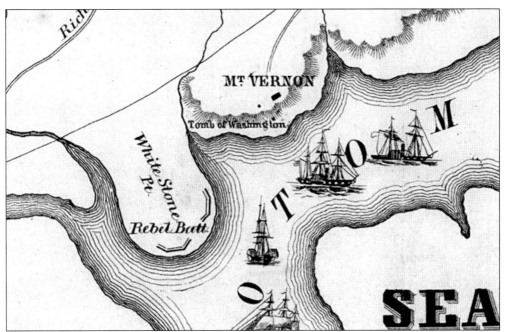

During the Civil War, the area around Mount Vernon was relatively peaceful. The Mount Vernon Ladies' Association asked both Union and Confederate forces to leave Mount Vernon alone, which for the most part worked. A scouting vessel of the Potomac Flotilla thought it observed Confederate batteries above the bluffs near White House Landing, but most likely saw the batteries from the Battle of the White House in September 1814. (GM.)

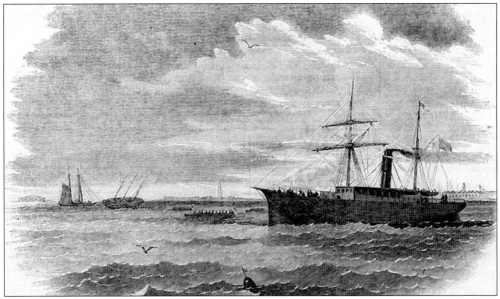

Several skirmishes occurred near Mount Vernon, including the burning of outbuildings on the nearby Otterback estate, but none were pivotal to the war. The steamer *Mount Vernon* of the Potomac Steamboat Company was a passenger boat bringing tourists from Alexandria to Mount Vernon and points beyond prior to the Civil War. The Union seized the ship and pressed it into service as part of the Potomac Flotilla. (PP.)

On May 14, 1861, the steamer *Mount Vernon* slipped into the mouth of Aquia Creek, about 20 miles south of its namesake plantation. Lieutenant J. Glendy Sproston, who was onboard, looked through his telescope to find a Confederate battery trained on them. Quietly, the ship backed out of the creek and steamed away before reinforcements arrived. The ship would survive the war and resume passenger service along the Potomac. (PP.)

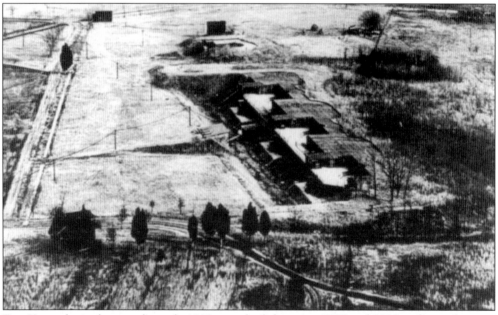

Fort Hunt, shown here in the early 1900s, was built between 1897 and 1898 and served as part of the defenses of Washington, D.C. on the Potomac River on what was part of George Washington's River Farm. Batteries Mount Vernon, Porter, Sater, and Robinson were constructed in 1899 and dismantled in 1917. The site was active in World War II, including secret intelligence activities interrogating German POWs. (VR.)

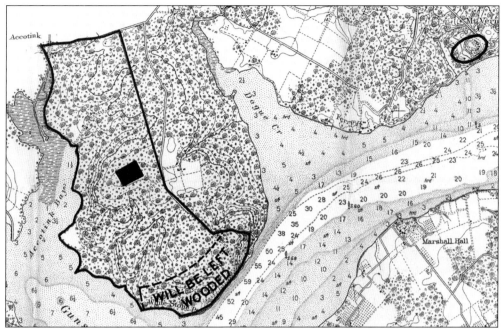

In 1910, the District of Columbia purchased two-thirds of Belvoir Neck for a criminal reformatory, which would have protected the Belvoir Manor area next to the river, shown here as "will be left wooded." From Mount Vernon, circled here, the Mount Vernon Ladies' Association pressured Congress to reconsider. It worked. The land was turned over to the War Department in 1912, and the reformatory was built in nearby Lorton. (GM.)

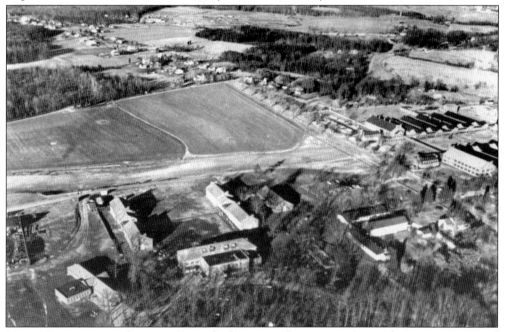

Lorton Prison was used to incarcerate both men and women and served as a minimum and maximum level facility for many years. Today, the property belongs to Fairfax County and the nearby Nike Missile site is proposed for the National Cold War Museum. (VR.)

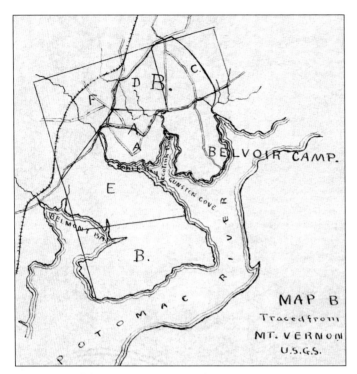

In December 1917, the War Department decided to build a home for the Army Corps of Engineers on the Belvoir Neck tract called Camp A.A. Humphreys. After purchasing the rest of the neck from John West, land between Pohick and Accotink Creeks and land across Route 1, the Corps of Engineers petitioned to purchase all of Mason Neck to the south if the camp continued to grow, but World War I ended. (FB.)

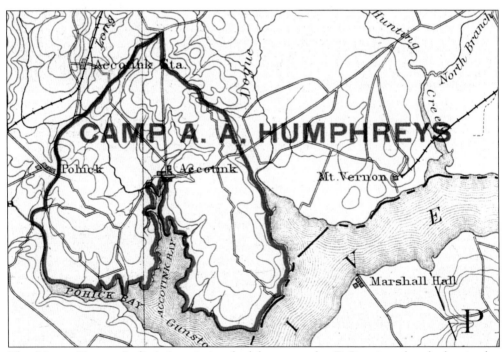

The Mount Vernon Ladies' Association had kept out the D.C. prison but had gained a military neighbor. Surrounding the little community of Accotink and abutting Pohick Church, Camp A.A. Humphreys trained tens of thousands of soldiers for service in Europe, including "the By God" Ty Cobb, who attended chemical warfare training school. (FB.)

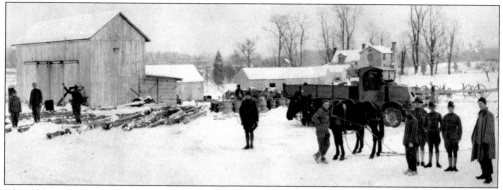

The old Ferdinando Fairfax and Philip Otterback farmhouse and barns were used as the first headquarters at Camp A.A. Humphreys from January to March 1918 and were later razed when the new headquarters was built. The first trucks and supplies made it to the neck on the frozen surface of the harsh 1917–1918 winter. (FB.)

An early spring at the end of February 1918 thawed the roads, and the heavy equipment and trucks trying to get from Alexandria to Camp A.A. Humphreys got mired down in the mud. The construction of the fort almost came to a standstill. The engineers searched for ways to keep the supplies coming in to the camp and yet deal with the huge mud problem. (FB.)

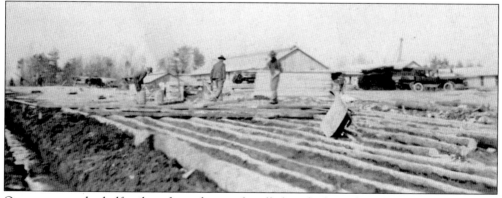

Over seven-and-a-half miles of wooden road, called a plank road, was constructed in early March 1918 at and near Camp A.A. Humphreys stretching from the Accotink Station on the main rail line to the west of the camp into the heart of Belvoir Neck. Large logs were first laid on the muddy and frozen surface and then covered with sawn wooden planks. (FB.)

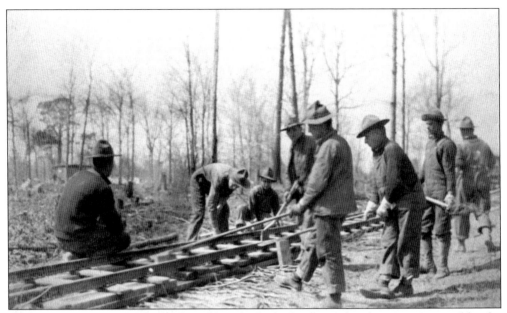

After the plank road was built, the soldiers built the longest railroad ever constructed by the army at that time to replace the wooden route. In addition to the industrial railroad, over 20 miles of a narrow gauge railway system, originally destined for Russia prior to their revolution, was installed as a "trolley" system on most of the streets of Camp A.A. Humphreys. (FB.)

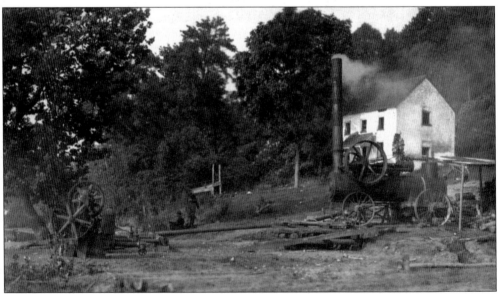

Three large, steam-driven pumps were installed on the Potomac River at the White House Landing and provided water for Camp A.A. Humphreys until the permanent water treatment plant was constructed. This is one of the last known photographs of the building known as the White House before it was razed by the army in the 1920s. (FB.)

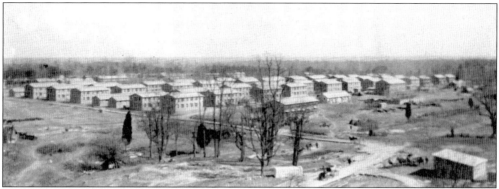

By March 1918, Camp A.A. Humphreys was taking shape. The old Ferdinando Fairfax and Philip Otterback farmstead had been razed, the former location near the trees in the foreground. The entire camp belonged to the Army Corps of Engineers and would remain their main home for over 70 years before relocating to Fort Leonard Wood, Missouri. (FB.)

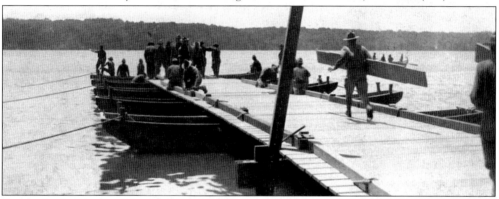

Ponton bridge construction was one of the main aspects behind the founding of Camp A.A. Humphreys on the Belvoir Neck. The engineers practiced bridge assembling on the Dogue and Accotink Creeks as well as the Potomac River. Many ponton bridge assembly records were broken by several of the regiments during their training at the camp. (FB.)

The gas and trench warfare schools at Camp A.A. Humphreys trained thousands of soldiers headed for the front lines in Europe in World War I. Moved from the American University Campus in the District of Columbia in 1917 to little Camp Belvoir (also known as Camp American University), the classes were no doubt responsible for saving countless lives of American soldiers. (FB.)

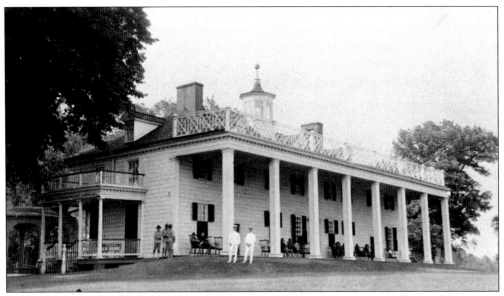

Nearby Camp A.A. Humphreys was Mount Vernon, by then enjoying almost 60 years of preservation by the Mount Vernon Ladies' Association. Normally not open to the public on Sundays, the Association made a special effort to accommodate the thousands of soldiers stationed at the camp. The commander of the troops only allowed the soldiers to leave the post on that day. (FB.)

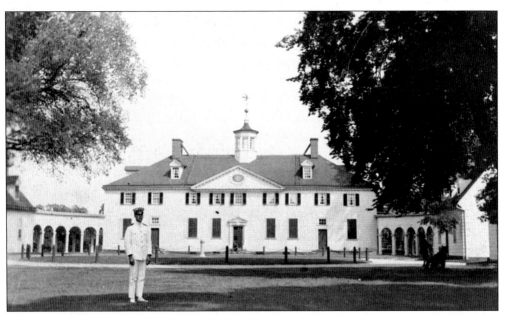

However, in the months during World War I that Camp A.A. Humphreys existed, of the tens of thousands of troops who trained and lived there, only a few hundred took the Association up on their discounted entrance price for Sundays. The Association wrote to the commander, stating more soldiers came to see Mount Vernon on Saturdays (when they were not allowed off post) to see the women who came down from Washington, D.C. (FB.)

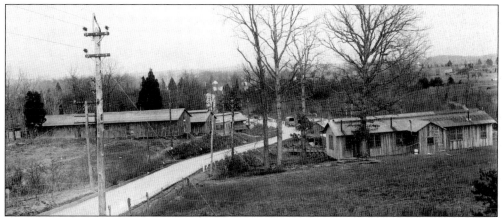

In the summer of 1918, the soldiers undertook a project that transformed land travel to Mount Vernon as well as Route 1 between the camp and Alexandria; they paved the highway with concrete. The highway work camp, under the direction of Maj. Guy Withers, was built just south of Little Hunting Creek where Route 1 and Old Mount Vernon Road intersect. (FB.)

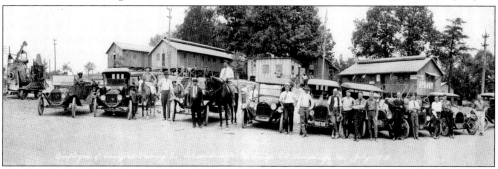

Named "Camp Gum Springs" for the African-American community north of Little Hunting Creek, the camp provided many of the local men with steady work during the highway project. (FB.)

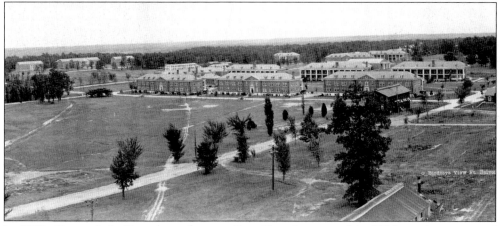

In 1922, Camp A.A. Humphreys became Fort Humphreys, and in 1935, at the request of President Franklin Roosevelt, the name was changed to Fort Belvoir, in honor of the Fairfax manor. This photograph shows the brick barracks and classroom buildings built in the late 1920s, which now constitutes the historic core of the post. (FB.)

At the beginning of World War II, Fort Belvoir realized the need to train thousands of soldiers for the two-front war effort. The Officer's Candidate School (OCS) on South Post trained some of the "90 day wonders," soldiers completing their training in three months' time. The Engineer's OCS graduated a staggering 650 men every two weeks during the peak of the wartime training. The Engineer's Officer Candidate School Association (TEOSCA) keeps the memories of these brave young men alive for future generations. (MHC.)

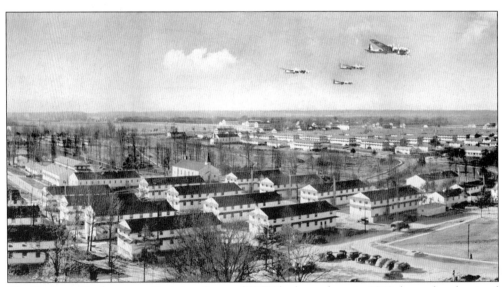

The Engineer Replacement Training Center (ERTC), shown here in 1942, housed and trained engineers soon to fight the technologically advanced war. The buildings were used for both the Korean and Vietnam Wars, but as of 2003, only one building from the ERTC from World War II survives. (FB.)

Five

THE MOUNT VERNON NEIGHBORHOOD

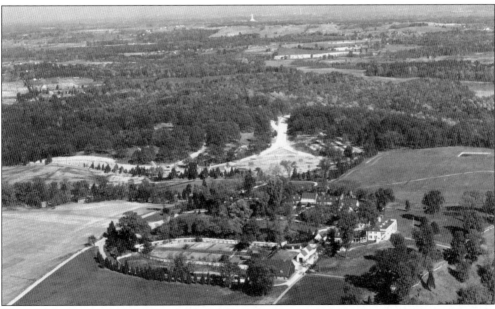

This 1932 aerial photograph of Mount Vernon shows the George Washington Masonic Memorial in the far distance, illustrating the open farmlands that still existed between Alexandria and Mount Vernon at that time. The George Washington Memorial Parkway had just been completed, shown in the center, which would lead to the development of the countryside shifting from a rural economy and farm houses to residential areas. (NARA.)

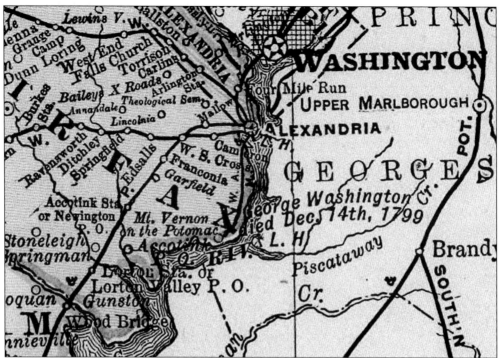

Throughout northern Virginia near Washington, D.C., the early 20th century saw the old stage stops and train stations become small communities. The historic estates, colonial plantations, and farms were being absorbed into the new landscape, shown in this 1896 map. This chapter presents the usually overlooked or unknown estates, popular spots, and communities in the region immediately around Mount Vernon and on the Maryland side of the Potomac River. (GM.)

The Fairfax tobacco barn, shown here in 1918, was located at White House Landing. A tobacco-rolling road led from the uplands to the barn and wharf next to the Potomac River. Built in the mid-1700s, the barn was used as a storage area for the fish seines cast from the shores by the Whitall and Otterback families for most of the 19th century. (FB.)

This photograph taken in the 1920s shows the old Fairfax tobacco barn and a pile of sawn wood next to the river. The unidentified woman enjoying the warmth of a campfire may be a relative of the Philip Otterback family that once owned the property. (FB.)

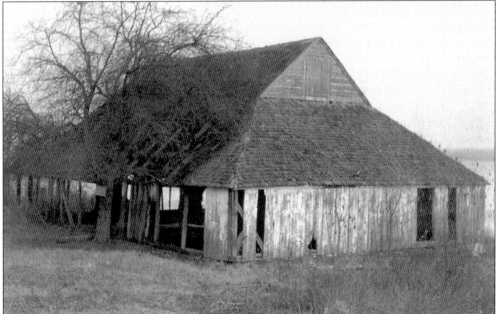

The Army Corps of Engineers assumed control of the Belvoir Neck in 1918 to the 1920s, when the U.S. Fish and Wildlife Commission built a fishery at the landing. The fishery built other buildings a few hundred yards south of the barn. The entire complex was razed in 1952, including the barn, and the area reverted back to the army. Then almost 200 years old, the barn could have been one of the oldest standing outbuildings in Fairfax County. (RGC.)

WHITE HOUSE FISHERY
SHAD & HERRINGS,

CAN be had, in any reasonable quantities and at Moderate prices, at the WHITE HOUSE FISHERY, of the Belvoir estate, on the River Potomac—and persons from the country, as well as water customers, are invited to that shore where they may expect the best of treatment, and every facility, in getting such supplies as they need, which that well known fishery, and the utmost attention of the subscriber can afford. Having been long experienced in that business on the Delaware river, and having taken the fishery for several seasons, he has caused a complete outfit to be made, not only for taking SHAD, as heretofore, but HERRINGS—of which it is well known that almost any number may be caught at that shore, when the gluts are in the river.— ☞ Country produce will be received as payment for fish at the Alexandria prices— such as Rye, Corn, Oats, Wheat, Bacon and Flour, together with Whiskey and Brandy. The subscriber will give the use of his sloops and schooners, gratis, to those who may wish to carry their surplus produce to market for inspection or sale—which may be done by the owners, whilst their spare hands remain with their waggons and carts at the landing to put up fish.

There is a house of entertainment close to the said fishery, where country customers may have comfortable lodging, horse feed, &c. at low rates.

As the Sandy-Point Herring Fishery at the mouth of Pohic Creek, on the same estate, is carried on this season by Mr. John Henderson, there will be the greater certainty that customers will not be disappointed in Herrings: the two fisheries being near together. SAMUEL WHITEALL.

White House Landing, March 22.

march 5 smwtf

By 1819, the first Quaker from Burlington County, New Jersey, to come to the Mount Vernon area, Samuel Whitall, advertised his fishery at the White House Landing on Belvoir Neck with a recently established place of entertainment and comfortable lodging nearby. Whitall could have been one of the first people to capitalize on the tourist trade to Mount Vernon by establishing this resort at the White House where steamboats landed. (AG.)

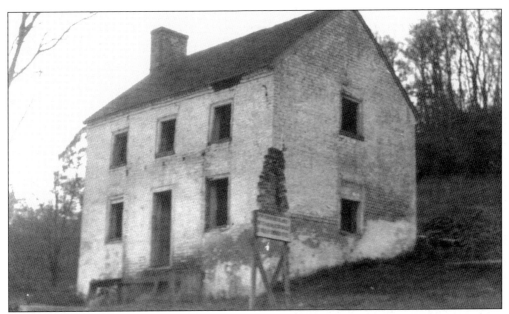

This building at White House Landing was labeled as the White House in a 1918 army report. However, archives show the White House was built in the mid-1700s and this structure has architectural styles of the early 1800s. Samuel Whitall built his establishment in 1819, and in 1820, the Belvoir tract real estate value jumped from $20,000 to $40,000, suggesting this building was Whitall's and not the real White House. (FB.)

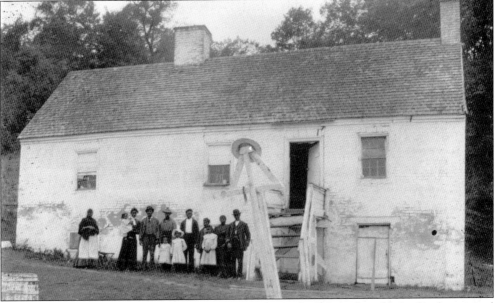

The White House Pavilion was locally famous in the mid-1800s and could also be the original Fairfax customs house and probably the actual White House. This building was located next to Samuel Whitall's house shown in the previous image. The Robert Tait family, standing in the photograph, had lived in the structure and operated the navigation light on the pole in the foreground for many years when "the Rambler," J. Harry Shannon, took this photograph in the early 1900s. (MCS.)

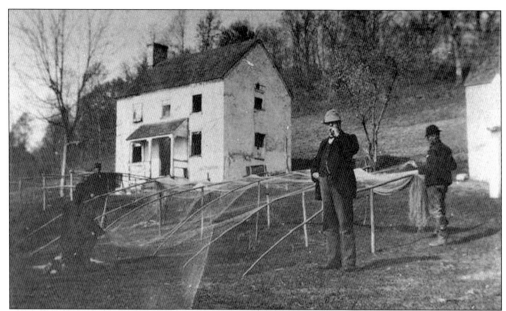

George Washington pulled in Fairfax fish seines at White House Landing in 1771. Samuel Whitall operated the fishery at the landing from 1819 to 1839, when he moved to operate the Mount Vernon fisheries. In 1839, Philip Otterback bought the Belvoir Neck, and his family, including son Benjamin Otterback, shown here in the late 1800s, ran the fishery until 1910. The structure at the right is the White House Pavilion. (FB.)

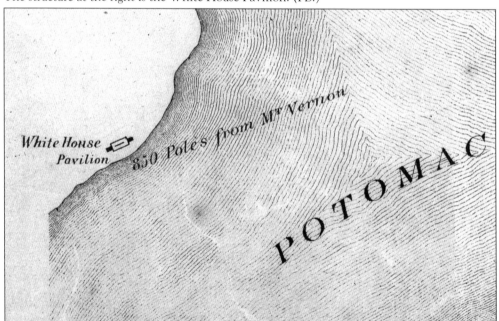

Lt. Robert Boyington, of the 105th Pennsylvania Volunteer Infantry Regiment, described the White House Pavilion on February 22, 1862. The pavilion had a kitchen, 100-foot long dining room, paper hangings and fresco paintings, upstairs bedrooms, a pool, ballroom, and a bar. Nearby was a 10-pin alley in a long and roomy building, possibly the tobacco barn, with fancy benches and beautiful fountains spouting water from lion heads located nearby. (GM.)

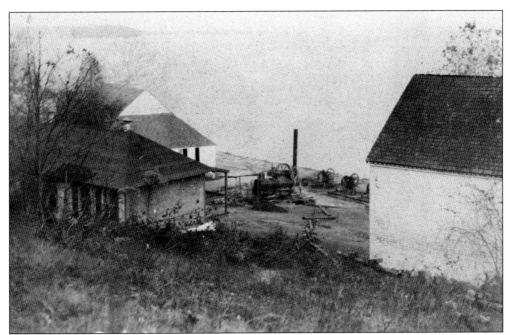

White House Landing had at least three buildings depicted here in 1918. Samuel Whitall's house is on the right, the customs house/White House Pavilion in the center, and the Fairfax tobacco barn is on the left. The pavilion had been modified from its original condition prior to 1918 and was by then called the Belvoir Club. (FB.)

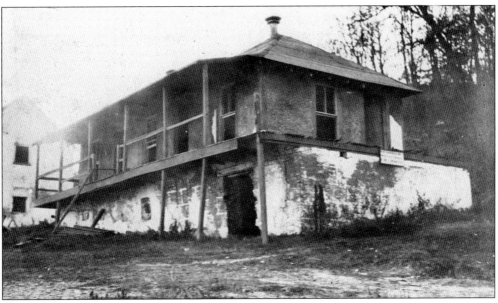

The Belvoir Club, shown in 1918, was the old White House Pavilion with the upper story removed and rebuilt. Someone painted large squares over the lower level brickwork, giving the appearance of a block foundation. The Army Corps of Engineers soldiers stationed at nearby Camp Belvoir from 1915 to 1917 probably made the modifications and used the building for a club. Samuel Whitall's house is to the left in the rear. (FB.)

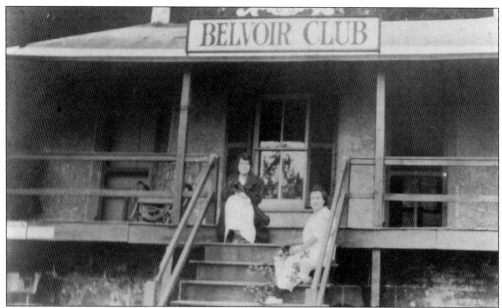

The Belvoir Club ceased operation during World War I on Camp A.A. Humphreys and the building was soon razed. Samuel Whitall's house was torn down in the 1930s. The landing had been a popular tourist spot for almost 100 years. Today, the Chaplain's House of Fort Belvoir is located on the footprint of the house that Samuel Whitall built with the same beautiful view of the Potomac River. (FB.)

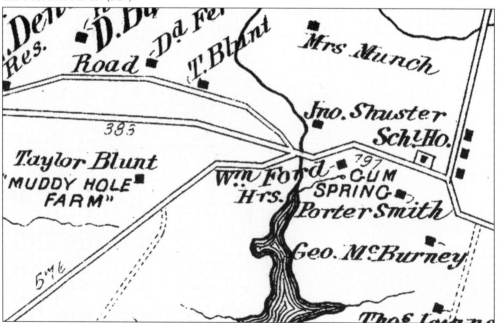

West Ford, a slave of George Washington's brother John Augustine Washington, was given his freedom in 1805 at the request of John's wife Hannah. Their son, Bushrod Washington, gave the freed Ford land just outside the Mount Vernon estate near Little Hunting Creek. Ford sold that land and bought a tract nearby, which became the nucleus for the freed African-American community named Gum Springs, shown on this 1879 map. (VR.).

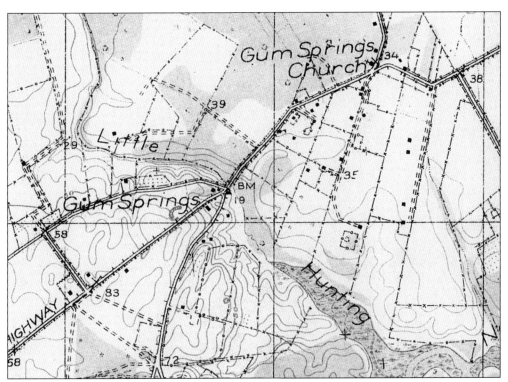

In 1857, West Ford divided his land into four parcels for his children. Those boundary lines were still visible as angled fence lines in this 1924 topographic map, seen below the Gum Springs Church. The map illustrates how small the community was, containing a church, school, and only a couple of dozen houses. The Quakers at Woodlawn provided the teachers in the early Gum Springs school system. (FB.)

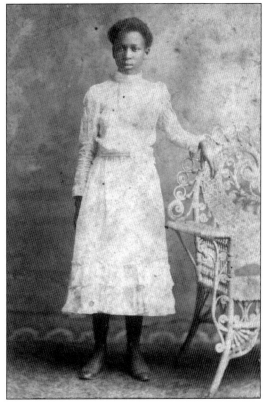

Ada Gray, from Gum Springs, shown in the late 1800s, married into the Brown family. The Brown, Holland, Quander, and Ford families are just a few of the surnames associated with Gum Springs. West Ford passed the land to his children without debt, who then divided the land so others could settle in the community when African Americans were discouraged from buying or had little money to buy land. (GSMCC.)

Residents such as John Brown, shown here in the late 1800s, built new houses as the Gum Springs community began to prosper. Mount Vernon employed many Gum Springs residents and the establishment of Camp A.A. Humphreys, now Fort Belvoir, has also helped the local economy. (GSMCC.)

Most of the laborers in Gum Springs worked on neighboring farms since the area had little industrial growth. A brick factory on River Farm provided work for over 100 employees, giving some stability. When the electric trolley was built in 1892, many residents left the farms, like this one shown in the 1940s near old Humphreys Peake, to get higher pay and steady work with the rail line. (VR.)

Gum Springs remained a quiet community where the neighbors all knew each other by name, socialized with each other, and worshiped with each other. Mrs. Ada Gray Brown is shown here talking outside of her house with Mary Etta Cotrell Brown around 1951. Mary Etta's grandson, Ron Chase, is the manager of the Gum Springs Museum and Cultural Center, housing the rich history of the community. (GSMCC.)

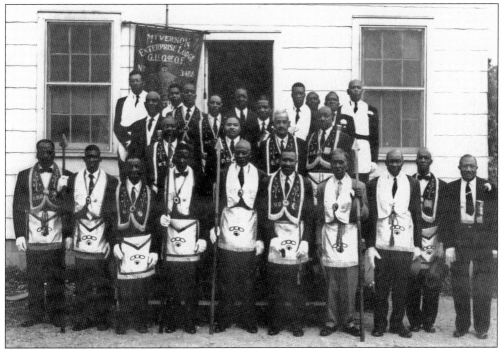

This photograph of the Odd Fellows Hall of Gum Springs was taken in the 1940s. The building is now gone and the colorful banner is now preserved in the museum at Gum Springs. (GSMCC.)

The Bethlehem Baptist Church in Gum Springs was established in 1867. The second church, shown here in 1961, was built in the 1930s. Today, the third church building stands erected next to the second one. The gentlemen in this photograph, from left to right, are Herbert Randall, Lawrence Ferguson, Carl Chase, and Eddie La Prade. (GSHS.)

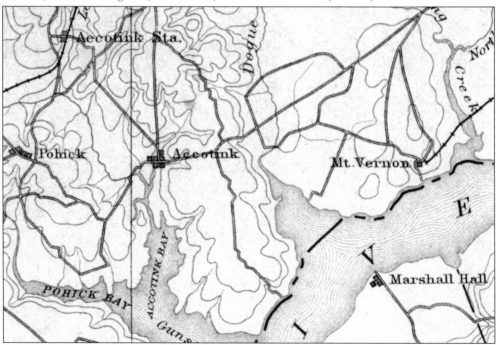

The little village of Accotink, across Belvoir Neck from Mount Vernon, is located at the intersection of Route 1 and old Backlick Road. By the mid-1700s, the town had a gristmill on Accotink Creek and an inn named the Royal Gorge, frequently attended by George Washington. The coming of the Quakers in the 1840s was a financial boost for Accotink, shown on this 1892 map. (GM.)

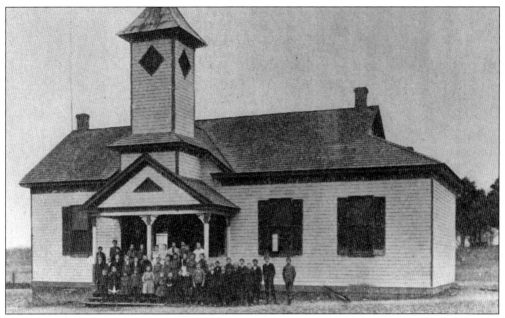

This photograph is of the old Accotink School taken in the early 1900s. The Civil War around Accotink was fairly quiet, although troops from both sides constantly traveled through the community. Only a few skirmishes occurred of any note, and Mosby's troops were seen quite often. (VR.)

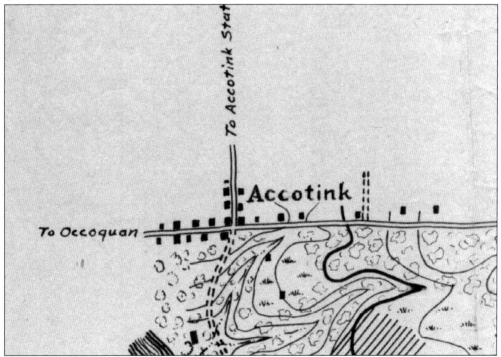

By 1918, when this map was drafted, Accotink still only had a few dozen houses, a church, school, and a couple of stores. Even though it was within two miles of the railroad station by the same name, industry and prosperity had never really found the community. (FB.)

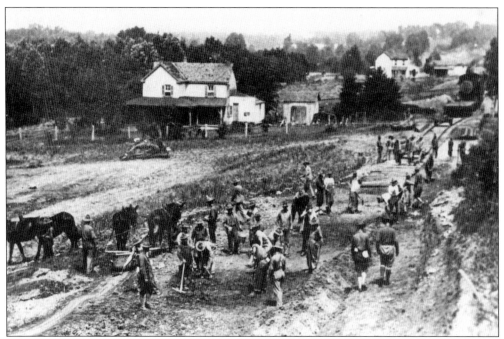

The Army Corps of Engineers built a rail line from Accotink Station on the main railway corridor to the west, through Accotink, as shown here in the summer of 1918, and onto Camp A.A. Humphreys. The rail line was touted as the longest railroad ever built by the Corps of Engineers up to that time, and it operated until the early 1990s. (WL.)

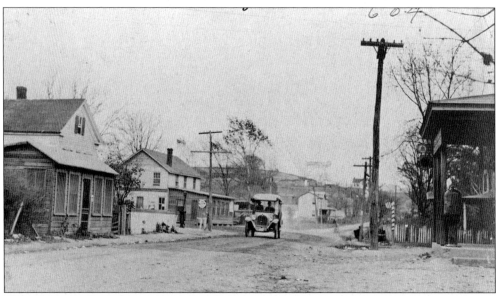

This 1918 photograph may be one of the earliest taken of Accotink just prior to the establishment of Camp A.A. Humphreys and the coming of the rail line through town. The houses were built almost directly on the street, similar to other colonial towns. Today, Accotink still has the same small hamlet feel and still has only a few dozen houses and a couple of stores. (FB.)

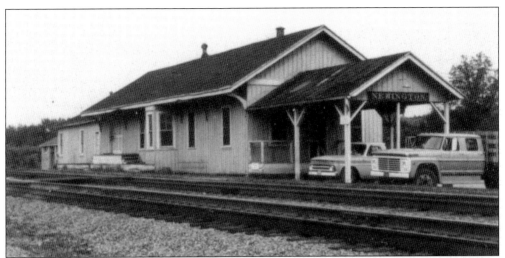

The depot at Accotink Station, shown here in 1970, was located at the Newington Post Office. The railroad spur to Fort Belvoir was only a few hundred yards south of the depot. During World War I, troops on a train had loaded up to head to Accotink Station from Camp A.A. Humphreys, received word the war was over enroute, and backed the train up to the post and disembarked. (FCPC.)

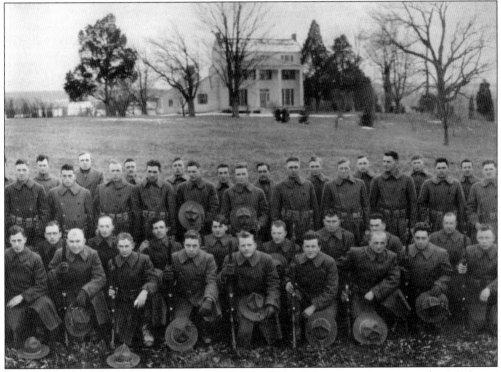

Mount Air, built in the late 1700s with several additions, was home to the McCarty, Chichester, and Kernan families. A tent camp for the 304th Engineers was at the site when Camp A.A. Humphreys was built in 1918. Mrs. Kernan let the soldiers stay at her place for free instead of paying $500 to a neighbor on "inferior" ground. In return, she received the surplus materials and the manure contract. (VR.)

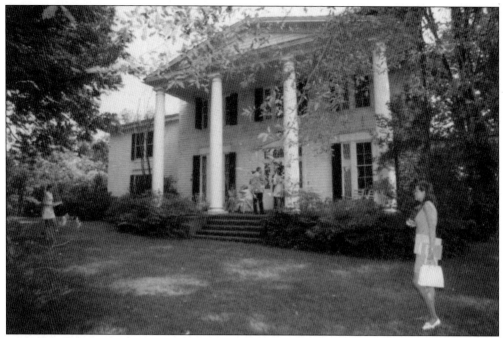

Mrs. Kernan got the better deal. The commander of the 304th said Kernan got several hundreds of dollars worth of surplus materials plus the manure contract. Basically, it cost the army more to have free rent with those conditions than to have paid the original $500 they were trying to save! The house, shown here in the 1970s, burned to the ground in 1992. (FB.)

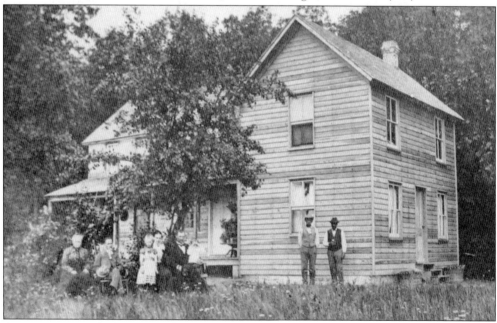

Otis Mason, son of John and Rachel Mason of Woodlawn, constructed this house, shown in the 1880s, across Route 1 from Woodlawn. The house has been preserved and is now part of a working horse farm under the National Trust for Historic Preservation as part of the Woodlawn and Pope-Leighey House property. (WL.)

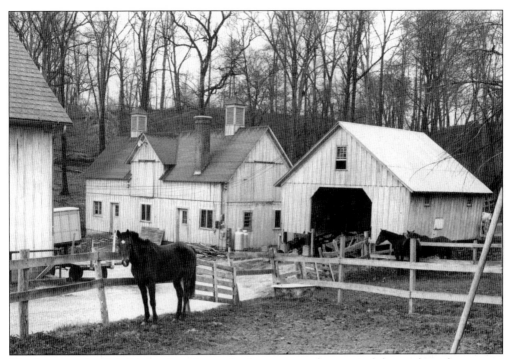

The barns at the Otis Mason farm have also been restored as part of the working farm across from Woodlawn, as shown here in the 1970s. (WL.)

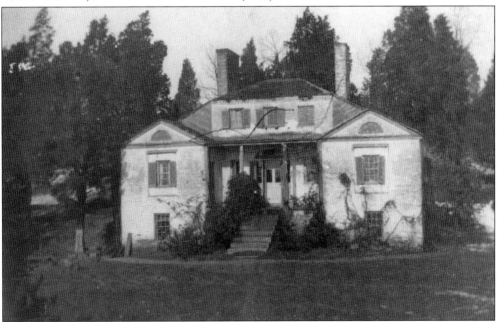

Huntley was constructed around 1820 by Thomson F. Mason, grandson of George Mason, the author of the Virginia Bill of Rights. Overlooking Hybla Valley, the estate commanded a picturesque view of the area. Possibly constructed with the influence of George Hadfield, architect of Washington, D.C.'s first city hall, this early 20th-century photograph illustrates the front façade. Today the house is protected as part of the Fairfax County Park system. (VR.)

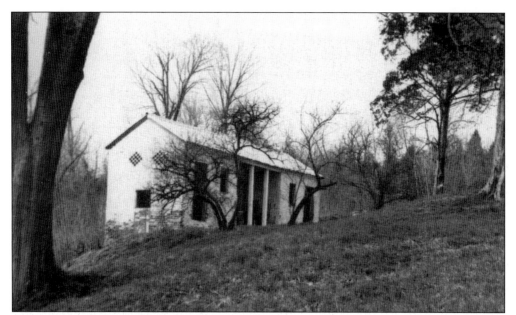

This building, located behind Huntley, is usually referred to as the "necessary" (toilet). Some locals believe the structure was a slave quarters, as over 85 slaves were located on the property at one time, but the building appears to have been built for storage rather than habitation. A brick icehouse, root cellar, and springhouse are located nearby and still survive. (VR.)

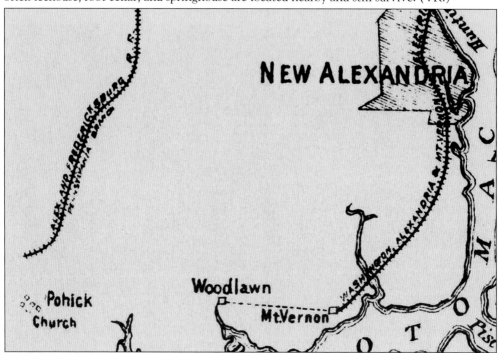

The New Alexandria Land and River Improvement Company developed a new community with factories and company housing south of Alexandria called New Alexandria. The intention of the development was to bring more commerce to the area and extend the electric trolley line to Woodlawn, where they would entertain clients, and then to Pohick Church. (WL.)

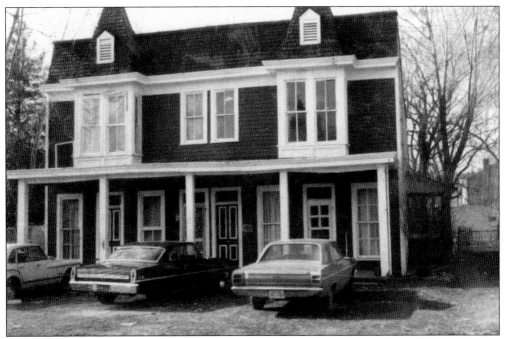

The New Alexandria development created jobs and prosperity for the region, but it was short lived. Only a few residential structures remain of New Alexandria from the early 1900s. This photograph of a triplex house was taken in the 1970s. (VR.)

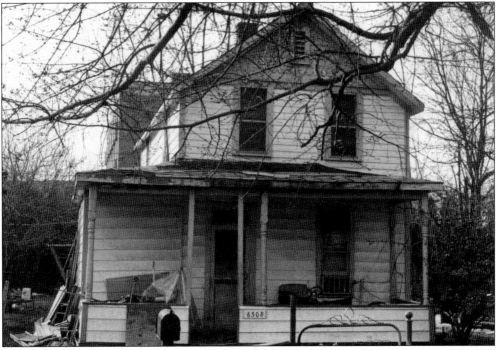

The area around New Alexandria is beginning to rebuild after years of decline. The few remaining houses of that era, as shown here in the 1970s, have not been restored and will probably be razed in time, creating room for new development. (VR.)

When the Army Corp of Engineers paved Route 1 from Camp A.A. Humphreys to Alexandria in 1918, they semi-straightened the winding Snake Hill. The building at the top of the hill is the old Groveton School House. In 1925, the building was purchased by the Catholic Church and turned 90 degrees and moved a few yards to become the first St. Louis Church at that site. (FB.)

The view west at the top of Snake Hill, shown here in 1918, illustrates how much dirt was excavated to form the new level roadbed. The house in the background is the Collard/Kirby farmhouse, still standing today. The older structure had burned a couple of years earlier, and this house was built on the old foundation. The family cemetery is still intact and bounded by an iron fence. (FB.)

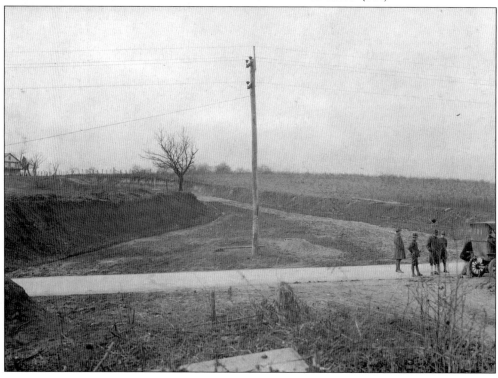

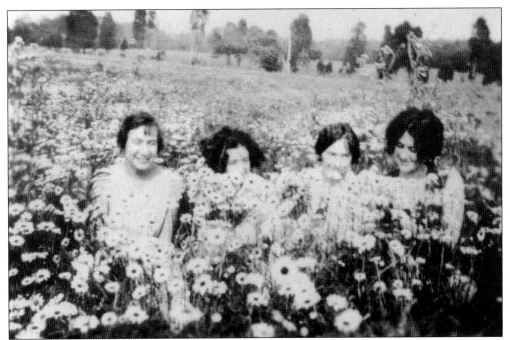

This 1920s photograph of a field of flowers was taken on the old Collard/Kirby farm near Huntley. The four young women are, from left to right, Virginia Miller, Ola Kirby, M. Wease, and Flora Kirby Potter. (VR.)

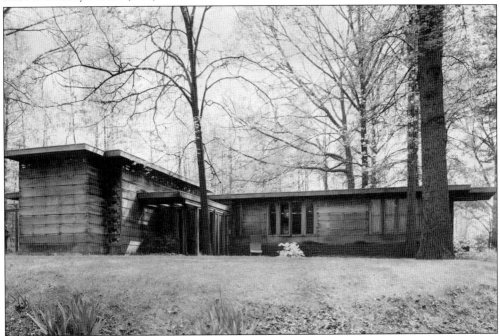

The Pope-Leighey House, part of the National Trust for Historic Preservation governing neighboring Woodlawn, was designed and built by Frank Lloyd Wright in 1939. Constructed as a stylish but affordable rural or suburban home type, the house is visited by hundreds of visitors each year as a rare chance to see an original Frank Lloyd Wright home. (PP.)

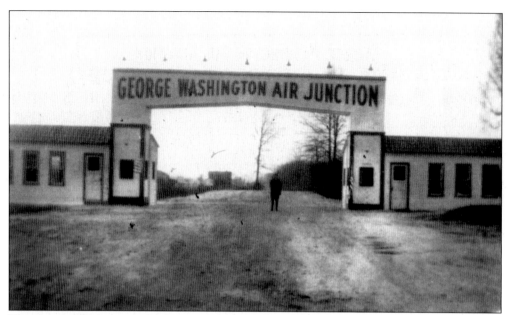

The George Washington Air Junction, perhaps one of the more elaborate schemes to develop the area in the Mount Vernon area, was located in Hybla Valley near Huntley Manor. The man behind the project, Henry Woodhouse, was born in Italy as Henry Casalegno and became the self-proclaimed president of the Aerial League of America. The front gates, shown in 1928, were on the Frederick Wease farm, seen in the background. (VR.)

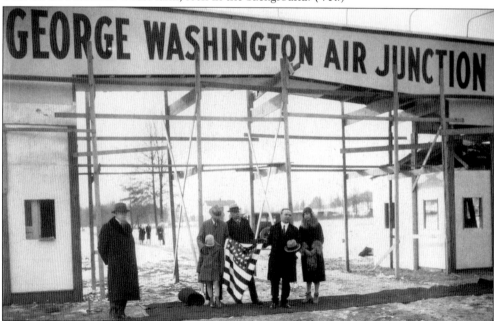

Woodhouse, shown with his hat off in 1930, stated the airfield was to have the longest airstrip in the world—7,500 feet—and would be the terminus of lighter-than-air craft for the dirigible traffic developing across the Atlantic in Germany. He dedicated the junction to the first President because Washington had supposedly been present at the first manned balloon flight in Philadelphia in January 1793. (AL.)

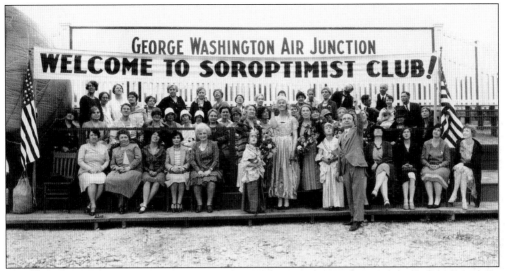

Woodhouse purchased over 1,500 acres mainly from the Huntley and Oakley farms from 1928 to 1930, now predominately Huntley Meadows Park. In 1929, the groundbreaking ceremonies were held on the site using "historically preserved" grandstands from Hoover's inauguration as an address was given to the International Soropimist Club, shown here at the ceremony with Woodhouse pointing to the sky. A reproduction of Washington's schoolhouse was also on the grounds. (AL.)

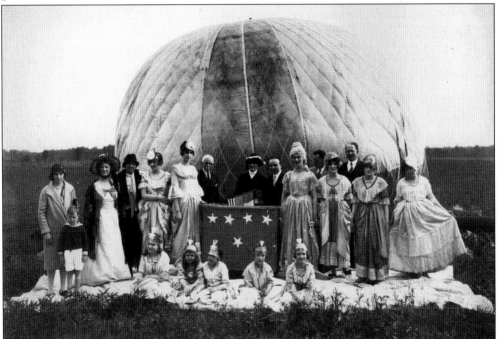

Supposedly an avid collector of Washington artifacts and papers, Woodhouse wanted to display them at the airstrip in a museum. To honor Washington during the inauguration ceremony, a replica of the first manned balloon ride in the United States, shown here in 1929, was launched from the site. Woodhouse was found to be mostly a fake and many of his "Washington" artifacts suspect, and the project failed. (AL.)

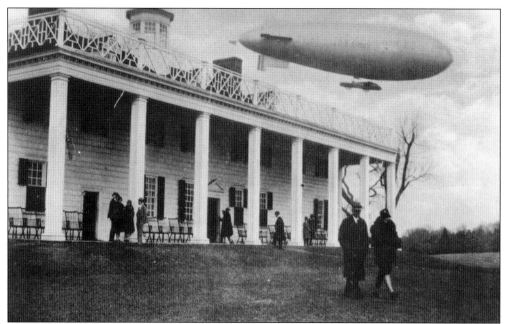

With Woodhouse's failure to bring dirigibles to Hybla Valley and the George Washington Air Junction also came the fact that scenes, such as this one of an army dirigible in the 1920s, would not be commonplace over Mount Vernon. No doubt if the plan had succeeded, the lighter-than-air craft would have hovered over the mansion annoying tourists on the ground. (MV.)

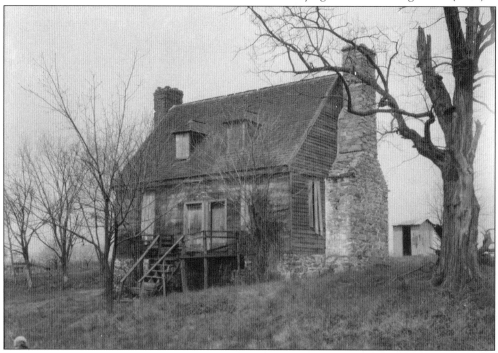

This structure is the old Colchester Inn, built on Occoquan Creek in 1753, several miles south of Mount Vernon. The community of Colchester has all but vanished and this structure is the sole surviving building from the 18th century and has been restored as a private residence. (PP.)

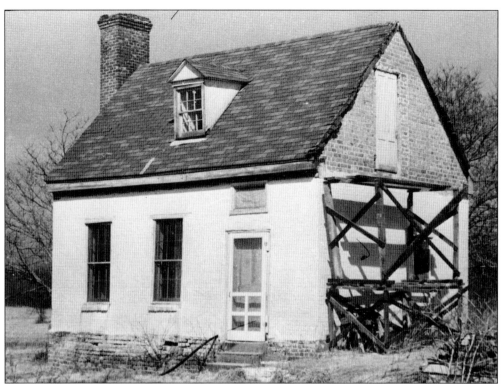

Lawrence Washington, a very distant relation to George Washington, bought the Belmont farm from Catesby Cocke in 1742, and a house was probably already standing on the property. This building, shown being remodeled in 1959, was probably a dependency or tenancy constructed by Catesby Cocke. Documentation at the Library of Congress erroneously states that Edward Washington was the owner of this house, not Lawrence. (VR.)

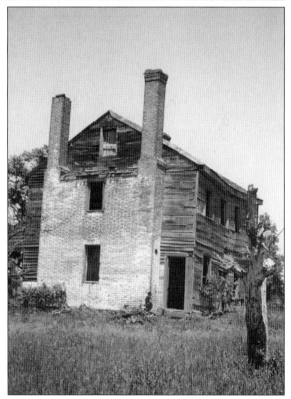

Descendants of William Hatton built the Hatton House near Hatton's Point in close proximity to Fort Washington in the late 1700s in Prince George's County, Maryland. The brick pent, or extrusion from the façade, shown here in the 1970s, contained both chimneys and two windows on two stories, a most unusual architectural style. An amusement park was also on the Hatton site but was in ruins by 1916. (PP.)

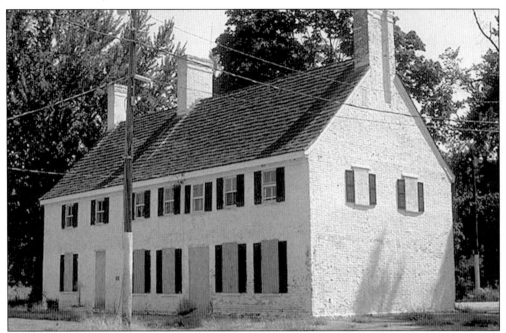

Marshall Hall, the home of Thomas Marshall, was located directly across the river from Mount Vernon on a patent of land called "Mistake" because of a surveying error. The large brick home was built around 1728, and after the Marshall family sold the place, the Mount Vernon and Marshall Steamboat Company bought the estate. (NPS.)

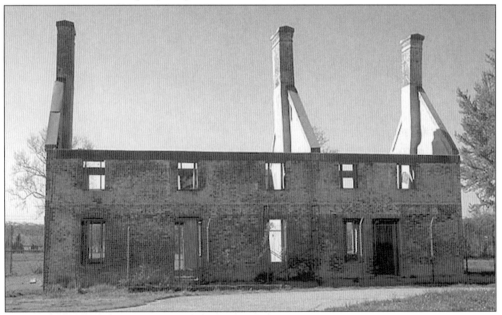

The Marshall Hall Amusement Park encompassed the house from the late 1800s to the mid-1900s and is discussed in chapter six in detail. Transferred to the National Park Service in 1976, Marshall Hall burned in 1981, leaving a brick shell. In January 2003, in a freak accident, a semi-truck and trailer plowed into the building, but it still stood tall and plans to restore are still being made. (NPS.)

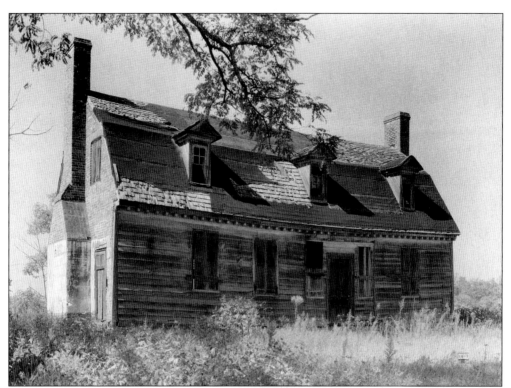

Built in 1704, the Lyles House was located on land called Want Water, near Broad Creek in Prince George's County, Maryland, across from Mount Vernon. It is unique in that the photograph shown here in the 1936 still had the walls as when it was erected with little, if any, modification. Thomas Addison probably had the house built, which in later years passed into the hands of Col. William Lyles. (PP.)

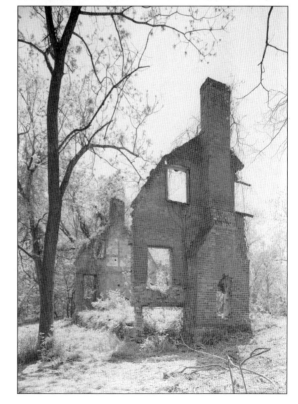

The Lyles House, now under the jurisdiction of the National Capital Region of the National Park Service, has only the two end brick walls and the foundation remaining, as the wooden fabric and interior have all but rotted away. The two ends exhibit a mirror image of each other, a ghostly reminder of the long history of the house site. (PP.)

Belleview, or the Lowe-Steed House, was built on land patented as Stoney Harbor given by Enoch Magruder to his daughter Ann Lowe in 1786. The land has passed on through 200 years and several generations of the same family to the present. The main portion of the house, shown here in 1989, was built in 1792 across the Potomac River from Mount Vernon near Fort Washington in Maryland. (GM.)

The date of construction for Belleview, 1792, was carved into a brick at the top of one of the chimneys. The four large chimneys—two shown here in 1989—surely must have kept the house warm in winter. The plantation complex had several interesting outbuildings, including a log meat house and one of the oldest tobacco barns in Prince George's County. (PP.)

Six

TRAVELING TO MOUNT VERNON

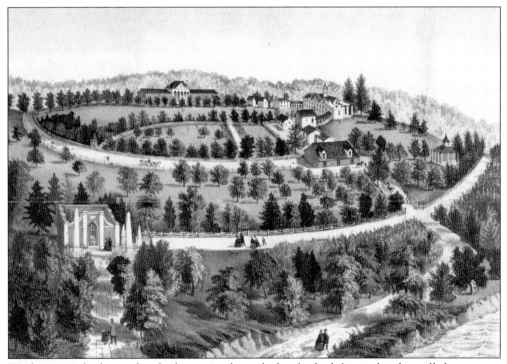

Washington's body was first laid in a simple vault, but he had directed in his will that a more substantial vault should be constructed. The new vault, shown in this early 19th-century painting, became the focal point of visitation at Mount Vernon after going through the mansion house. Visitors, including Lafayette in 1824, paid homage, expressing deep open sorrow even 20 years after Washington's death. (PP.)

After the Mount Vernon Ladies' Association bought the estate, tourism became organized. The cover of the 1892 visitor's guide to Mount Vernon was a major undertaking by author Elizabeth Johnson. She had been in contact with the Ladies' Association and their desire for changes and corrections made in the guide. Additionally, the ladies' group wanted to impress visitors coming for the G.A.R. Encampment that year at Mount Vernon. (LC.)

NEW LINE

AND

LOW FARE!!

THE NEW, LARGE AND ELEGANT STEAMER

MARY WASHINGTON,

M. E. GREGG, COMMANDER,

Will, until further notice, run as follows:

FARMERS' ACCOMMODATION

Will leave Accotink daily, Sundays excepted, at 6 a. m., precisely, for Alexandria and Washington, stopping at Gunston Hall, Whitehouse, Marshall Hall, Mount Vernon, Fort Washington and Collingwood.

MOUNT VERNON TRIP

For the accommodation of Excursionists, Pleasure Parties, Parents and Children, will leave Washington at 10 a. m. precisely, (city time) for Mount Vernon, giving the passengers ample time, not only to visit the Mansion and the Tomb, but all the classic grounds surrounding.
 Fare from Washington and Alexandria to the new landing called "Mount Vernon Springs" and return, ONLY FIFTY CENTS; children under 12 years, half price. Parties visiting the Mount Vernon Mansion will be charged 25 cents extra for stage fare—one mile over an excellent and delightful road—and 25 cents, the admittance fee charged by the Mount Vernon Association.
 Parents, Teachers and Guardians, bring out the little ones, and give them a safe and delightful trip on the new and commodious steamer to Mount Vernon Springs and the Tomb of Washington.
 Returning to Accotink will leave Washington at 4 p. m., touching at all the intermediate landings.

The steamer *Mary Washington* was built by Quaker Paul Hillman Troth in 1874 in the little town of Accotink. Designed to hold 1,500 passengers, the boat was owned by Troth's Upper Potomac Steamboat Company from 1874 to 1882. After 1882, a series of owners ran the steamer, the last of which converted her into a clubhouse near Georgetown, D.C. She burned and sank into the Potomac River in 1902. (WL.)

Probably the most beloved captain of the steamers to Mount Vernon and on the Potomac River was Capt. Levi Lowell "L.L." Blake. Blake was born in Vermont, and for a while, he lived in Montana as an Indian Agent on the Jocko Reservation. In 1870, he moved to Washington, D.C. and co-founded the Mount Vernon and Marshall Hall Steamship Company with Joseph McKibben. (PP.)

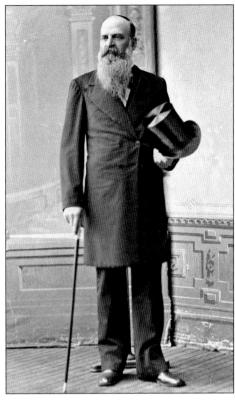

Captain Blake worked hard at the business partnership he had with the Mount Vernon Ladies' Association. Giving them a percentage of the take, he would give them discounts when rider membership was low; when the trolley came, he helped them through the transition. Upon his death in 1904, the Ladies' Association gave his widow a pension for his devoted service and his body was shipped back to Vermont for burial. (PC.)

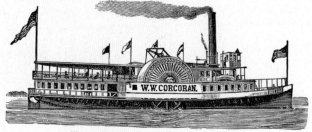

THE STEAMER

W. W. CORCORAN,

Which has been recently built and furnished,

L. L. BLAKE, - - Captain,

Is the only Boat allowed to land Passengers at Mount Vernon Wharf.

ROUND-TRIP ONE DOLLAR,

Including admission to Mansion and Grounds.

STEAMER leaves Seventh-Street Wharf DAILY (Sundays excepted) at 10 A. M., and returns about 3 P. M.

J. McH. HOLLINGSWORTH,
Sup't Ladies' Mount Vernon Association.

L. L. BLAKE,

The *WW Corcoran* was the first ship built for Captain Blake and McKibben and was inaugurated into service in 1878. Named after a wealthy Georgetown, D.C. businessman, the *WW Corcoran* plied the waters of the Potomac River until she burned in 1891. The fire was so hot that she was cut loose so the pier and other ships would not catch fire. (LC.)

THE IRON AND STEEL STEAMER

CHARLES MACALESTER,

Which has been recently built and furnished,

L. L. BLAKE, - - Captain,

Is the only Boat allowed to land Passengers at Mount Vernon Wharf.

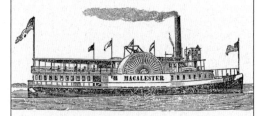

ROUND-TRIP ONE DOLLAR.

Including admission to Mansion and Grounds.

Elegant Café on the boat. Meals and lunches served promptly. Mount Vernon guide-books can be procured on the boat.

From April 15th to September 15th, steamer leaves Seventh-street Wharf *daily* (Sundays excepted) at 10 A. M. and 2.30 P. M., returning at 2 and 5.45 P. M.

From September 15th to April 15th, the steamer leaves at 10 A. M., and, returning, reaches Washington at 3 P. M.

HARRISON H. DODGE,
Sup't Ladies' Mount Vernon Association.

L. L. BLAKE
Captain Charles Macalester.

The steamship *Charles Macalester* was named for the father of one of the Mount Vernon Ladies' Association members, Mrs. Lily Macalester Laughton, a famous Washington, D.C. hostess. The ship was affectionately known as "Charley Mac" by the steamboat people and was built almost exclusively for the service from Alexandria to Mount Vernon and Marshall Hall across the Potomac on the Maryland Shore. (LC.)

104

The *Charles Macalester*, shown here in the 1920s along the Potomac River, traveled thousands of miles on the river carrying untold numbers of passengers, groups, and dignitaries. Only during refitting and ice build-up on the river did the ship not make her runs. The approach to the Mount Vernon wharf had silted in over the years, and the large steamers had trouble clearing the bottom during low tide. (PP.)

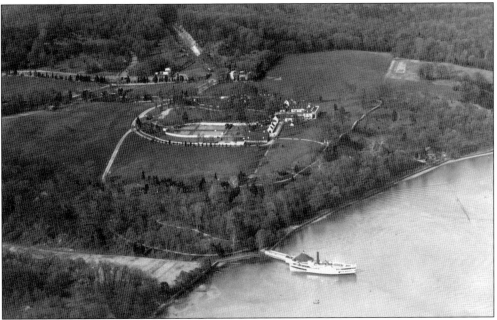

The Ladies' Association approached the Army Corps of Engineers about the issue, who stated they would not pay for the dredging for only one entity. Therefore, the ladies raised money to have it done themselves. In this 1920s photograph, the flat area to the left of the *Charles Macalester* was called Hellhole where mud from the dredging was placed to fill in a swampy area, hence the name by Washington. (NARA.)

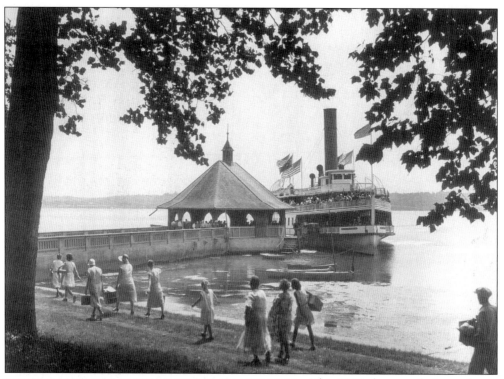

MT. VERNON!
TOMB OF WASHINGTON.

ELECTRIC RAILWAY
COMMENCING THURSDAY, 22D INST.

OPPORTUNITY TO VISIT

ALEXANDRIA, CHRIST CHURCH
(Washington's Church.)

And other Historic Points; Delightful Scenery; Magnificent New Cars.

DIRECT TO THE GATE OF THE MANSION HOUSE.

Take Saloon Steamers from foot of 7th street every hour.

Special Excursion Tickets, 30c. Round Trip.

Or Railroad Trains of the Pennsylvania Line, from 9th street and Maryland Avenue, Fare, 45c. Round Trip.

F. A. REED,
Supt. Washington, Alexandria and Mt. Vernon Electric Railway Co.

STRIDER, PRINTER, ALEXANDRIA, VA.

This 1932 photograph shows the steamer *Charles Macalester* at the Mount Vernon Wharf on a typical day. The steamboat line paid the Mount Vernon Ladies' Association a percentage of the receipts and, at various times during their long association, gave discounts or did not raise rates to encourage travel. The *Charles Macalester* had a long life from 1890 to the 1940s before being scrapped. (PP.)

First proposed in 1886, an electric trolley service to Mount Vernon was not constructed until 1892. The Mount Vernon Ladies' Association fought the establishment of the line because of the long history with Captain Blake and his company. Additionally, the rail line potentially brought a different crowd that would lounge around the area waiting for several trolleys and did not have to leave when the daily boat left. (AL.)

Once the Washington, Alexandria, and Mount Vernon Railway service was inaugurated, the Ladies' Association embraced the railroad and the ship line both as partners providing a steady income for the Association. Since the ships were iced up during much of the winter, the trolley could run almost year round. However, a few snowstorms stopped the trolley service at times, always causing concern in a drop of the ladies' revenue. (WL.)

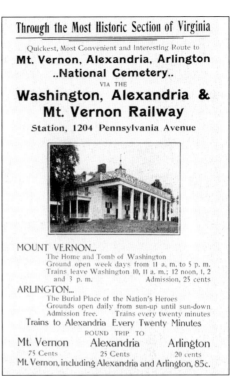

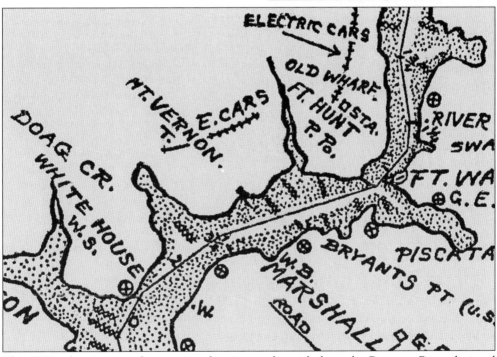

This 1892 advertisement for camping, boating, and travel along the Potomac River depicted the electric "cars" down to Mount Vernon. The promotional poster also indicated that water (W) and supplies (S), as well as camping (circled X) were available at the White House on Belvoir Neck. The x's in the river represent the places where fish seines were placed. (GM.)

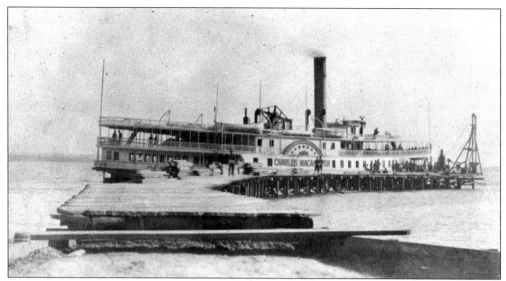

A new dock was built near the base of the bluff below the Belvoir ruins specifically for the *Charles Macalester* by the Army Corps of Engineers when Camp A.A. Humphreys was established in 1918, shown here. The steamer also stopped at the new dock for the engineers near Camp Belvoir about one mile from the Belvoir dock. The soldiers frequently used the steamers to get to Washington, D.C. and back. (FB.)

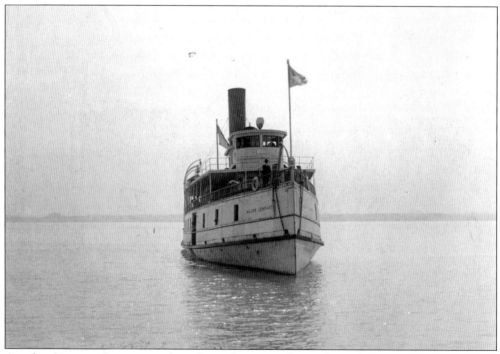

Another Potomac River steamship plying the waters from Alexandria to Mount Vernon was the *Major L'Enfant*, shown here almost to the Camp A.A. Humphreys dock near Camp Belvoir in 1918. (FB.)

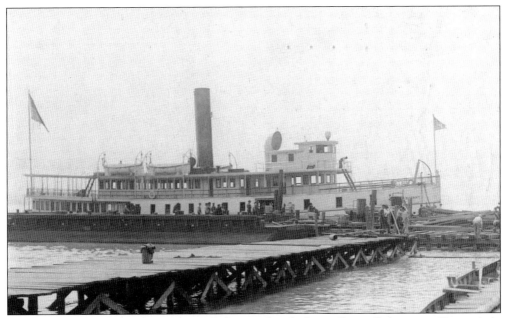

This photograph shows the *Major L'Enfant* at the docks at Camp Belvoir on Camp A.A. Humphreys in 1918. The dock on the right had a narrow gauge rail spur to the edge of the pier for loading and unloading. (FB.)

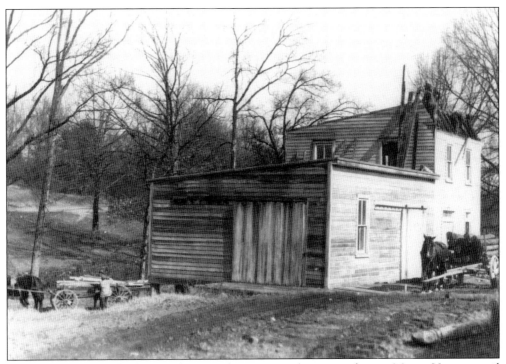

The trolley line was the biggest threat to the passenger boats traveling to Mount Vernon until the 1930s. This is a 1918 photograph of the electric trolley freight house at Mount Vernon to the west of the trolley line loop. (JGL.)

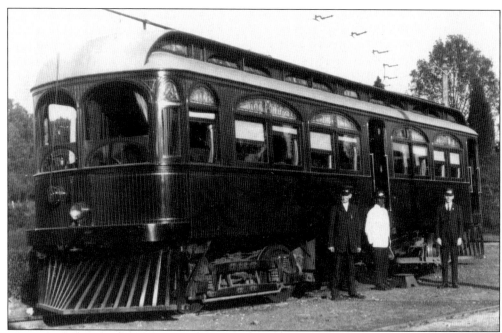

The Washington, Alexandria, and Mount Vernon Electric Railway Company purchased this parlor car, called the "Mount Vernon," around 1914 from the president of St. Louis Street Railway Company. The car, shown here in 1925, was the most elegant in the rail line and had Tiffany fanlights. (JGL.)

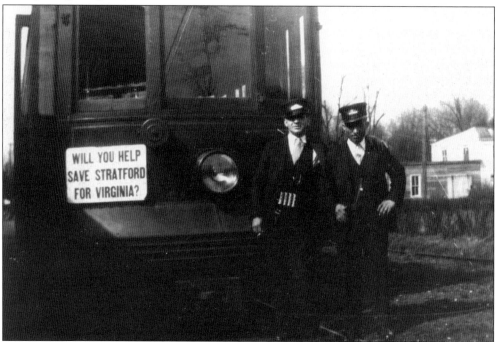

Stratford Hall, the ancestral home of Robert E. Lee's family in east-central Virginia, was the focal point of this placard on a trolley car at the Mount Vernon terminus in 1925. The freight station house is in the background to the right. (JGL.)

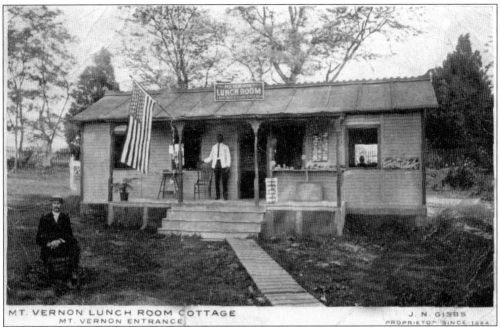

MT. VERNON LUNCH ROOM COTTAGE
MT. VERNON ENTRANCE

J. N. GIBBS
PROPRIETOR SINCE 1884

Joseph Norman Gibbs, the son of a New Jersey Quaker, asked the Ladies' Association for permission to set up a lunch counter outside the gates at Mount Vernon in 1884, prior to a trolley line or major highway. This rare postcard depicts Gibbs's first lunch room at Mount Vernon, erected in 1884. Gibbs and a succession of relatives would run the concessions at Mount Vernon until the 1920s. (JGL.)

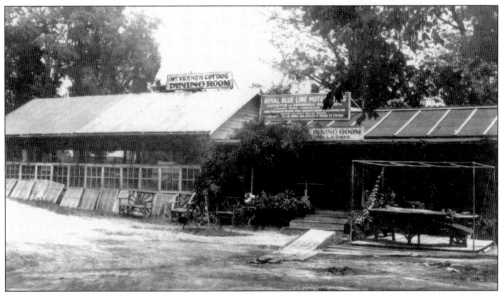

This undated photograph shows the original Mount Vernon lunch room (right) and the newer dining room added when the trolley line was built (left). An advertisement on the roof is for the Royal Blue Line Tours. At this time, the lunch room was operated by Fanny Truax Gibbs, related to the original lunch room concessionaire Joseph Norman Gibbs. The building was moved north on Route 235 for a residence. (JGL.)

111

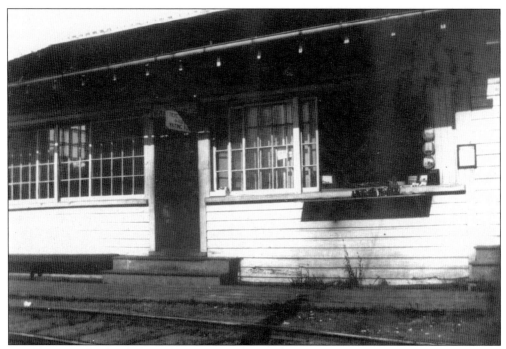

This undated photograph is the first lunch room at Mount Vernon during the electric trolley era. Coffee mugs line the outside ledge at the ticket counter. (JGL.)

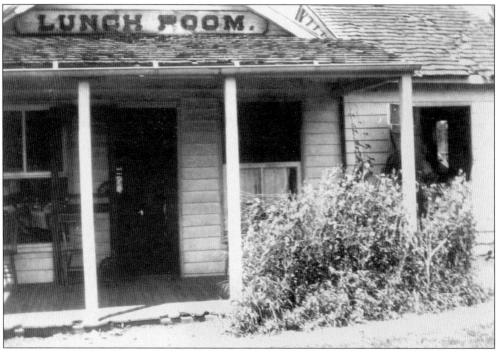

The Washington, Alexandria, and Mount Vernon Electric Railway lunch room at Mount Vernon was at the end of the trolley loop. The famous Tea Room has not yet been constructed in this photograph. (JGL.)

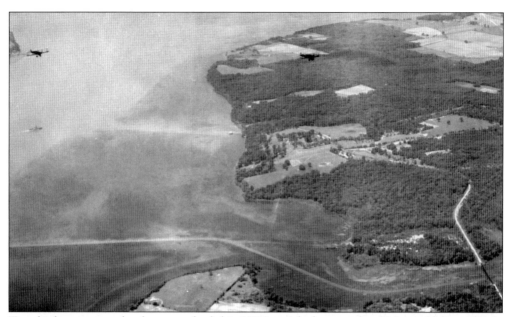

Two biplanes grace the foreground of this 1926 aerial photograph of Mount Vernon Neck, possibly the earliest aerial photograph of the region. The deep channelized Little Hunting Creek is at the bottom with the electric trolley line bridge in the bottom right corner. Mount Vernon is located in the right central portion and a ship is approaching the dredged entrance to the Mount Vernon Wharf from the left center. (NARA.)

A short trunk line of the electric trolley ran from Mount Vernon to Camp A.A. Humphreys (now Fort Belvoir) from the fall of 1918 to the summer of 1920. This 1918 photograph shows the overhead crossing of the trolley line leading west of Mount Vernon with the Tea Room in the background. Ties for the rail line were stacked in front of the Tea Room. (FB.)

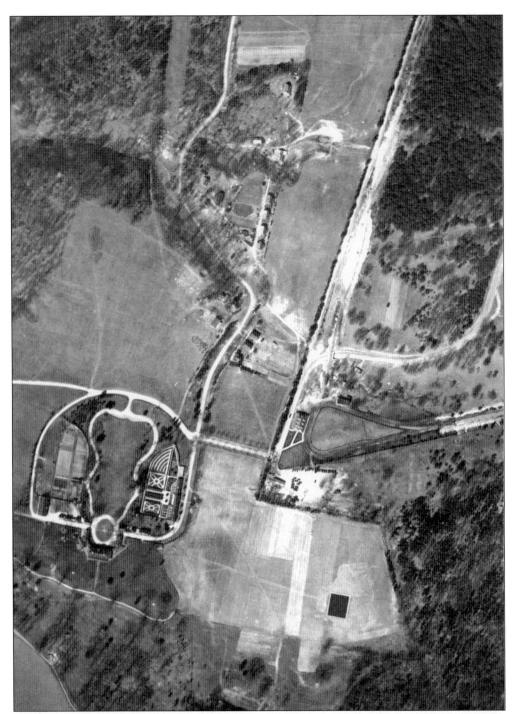

This rare aerial photograph from 1926 shows the best early imagery of Mount Vernon available from this angle. Wonderful details of the mansion and garden areas can be seen. The electric trolley line terminus loop can be seen in the bottom center and the parking lot is to the left of the loop. The angular fenceline represents the edge of the 200 acres the Ladies' Association bought in the 1850s. (NARA.)

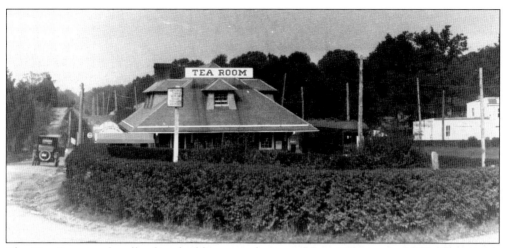

The Tea Room and trolley line buildings are shown at Mount Vernon in 1925. The view is looking west where the cut for the line to Camp A.A. Humphreys was previously located, seen behind the left side of the Tea Room. (JGL.)

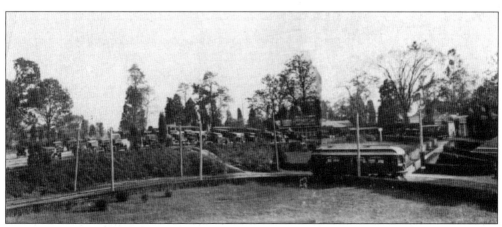

This old Mount Vernon parking area and trolley car panoramic photograph was taken in 1930. (JGL.)

The Washington, Alexandria, and Mount Vernon Railway tracks just south of Alexandria, Virginia are pictured in the 1930s before they were torn up. The little building was the Dyke station stop. (PP.)

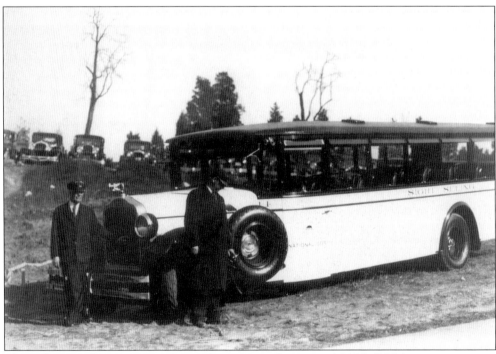

This sightseeing bus picture at Mount Vernon was taken around 1925. (JGL.)

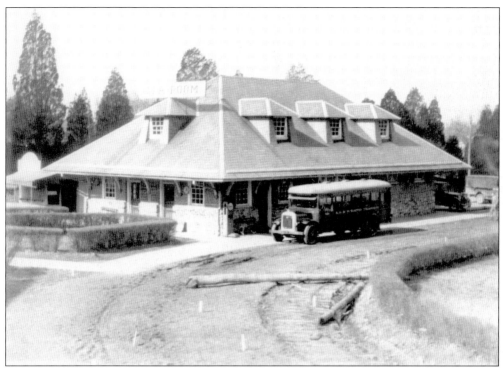

The Tea Room and an A, B, and W bus at Mount Vernon are shown here in 1931. Note that the rails and ties have already been removed from the old trolley line as the new George Washington Memorial Road was being constructed to the site. (JGL.)

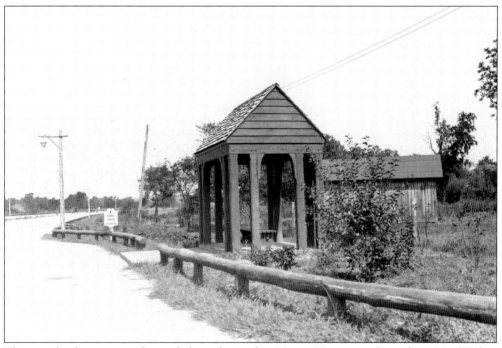

This wooden bus stop was located along the road to Mount Vernon in the early 1930s. (PP.)

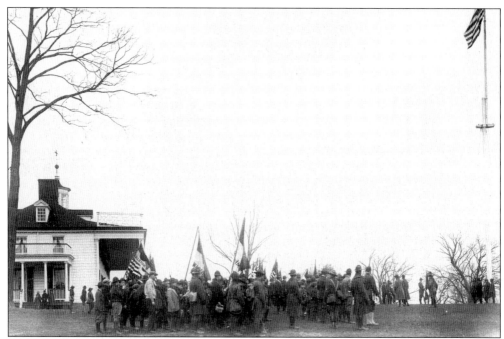

People from every walk of life, from every religion, from every state and nation, have traveled to Mount Vernon to pay homage to George Washington and to see his home. The Boy Scouts of America shown in the photograph must have been very proud to see the flag wave over the grounds of the estate. (PP.)

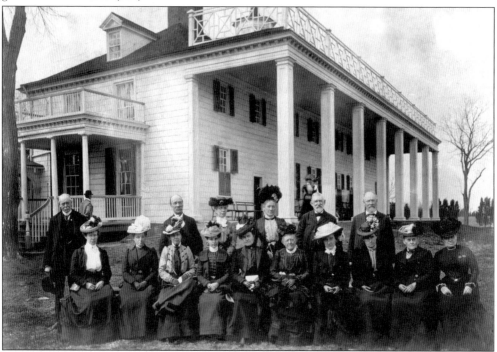

This 1899 photograph, also used on the cover of this book, was labeled "Group of 16 people posed in front of the George Washington home at Mount Vernon Estate." (PP.)

Many tourists to Mount Vernon would bring picnic baskets to have an outdoor lunch on the grounds or at other points to which the steamers might take them. These ladies were photographed in 1918 at Belmont Station between Alexandria and Mount Vernon. (JGL.)

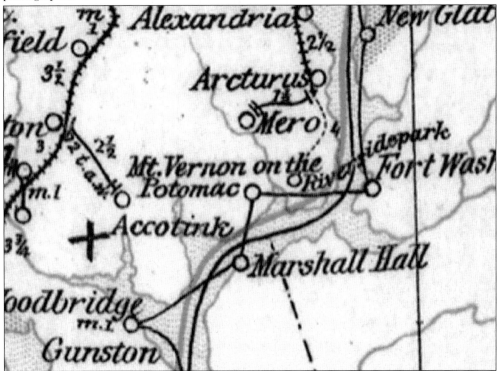

Jay Gould, eccentric millionaire, donated 33.5 acres to the Mount Vernon Ladies' Association in 1893, encompassing the terminus of the electric trolley line. The donation attempted to keep an amusement park from being built next to Mount Vernon. Riverside Park (Johnson Springs or Collingswood Beach), shown on this 1896 map, was an African-American amusement park built on the Potomac River in the 1890s, possibly the park in question. (GM.)

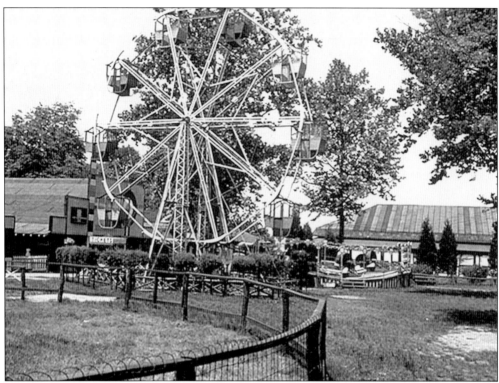

Marshall Hall, the plantation, was discussed in chapter three. Marshall Hall, the amusement park, built around Marshall Hall in 1889, was a huge draw for the Washington Metro public. The park contained a pavilion, jousting matches, arcades, and this ferris wheel from an undated photograph. The park was one of the favored stops of the passenger ships on the Potomac River, such as the *Charles Macalester*. (NPS.)

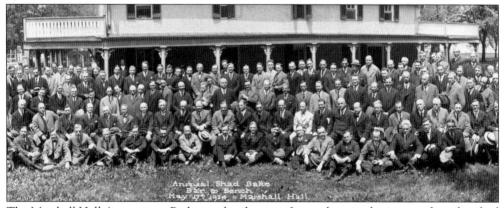

The Marshall Hall Amusement Park was also the site of many large gatherings, such as this shad bake for a group of lawyers. The photograph was taken in May 1924 and labeled "from Bar to Bench." (PP.)

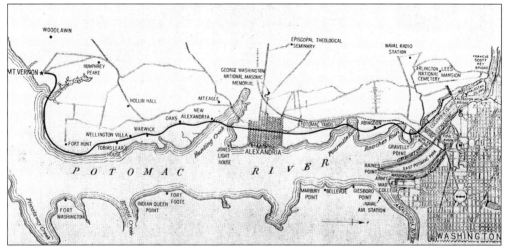

The George Washington Memorial Parkway, finished in 1932, was constructed to link Washington, D.C. to Mount Vernon during the bicentennial celebration of Washington's birth. The roadway, shown in this 1932 planning map, replaced the failing electric trolley line built in 1892. (GM.)

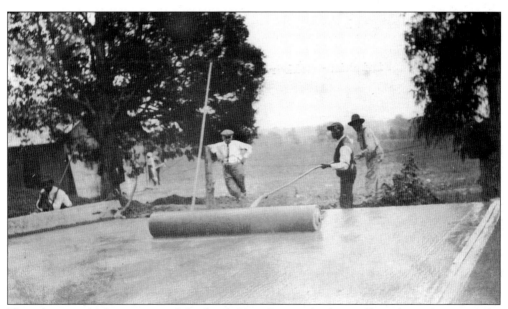

This photograph shows some of the local Gum Springs workers rolling the concrete on the Route 1 paving project in the summer of 1918. Even though Alexandria was only eight miles away, the workers of that town did not want to travel to the work site on a daily basis, giving the Gum Springs work force more job opportunities. The road allowed for motoring tourists to travel to Mount Vernon all year round. (FB.)

121

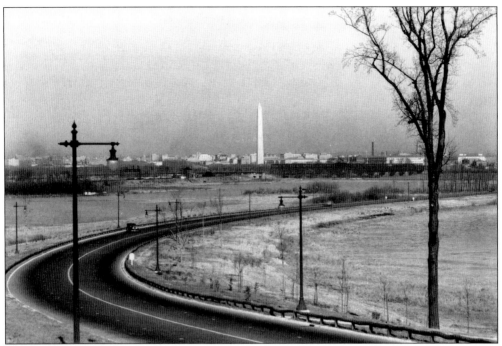

The George Washington Memorial Parkway is shown in this 1932 photograph in front of the Washington Memorial near where the Pentagon now stands. (PP.)

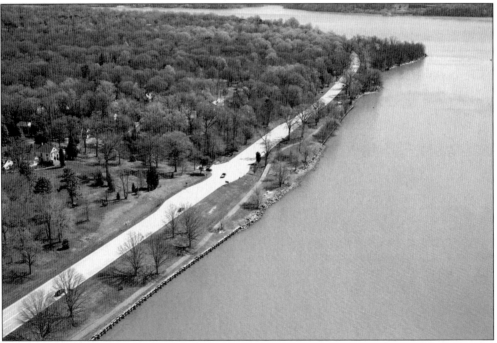

One of the biggest draws for the public about the George Washington Memorial Parkway was the fact that it skirted the Potomac River almost the entire length from Alexandria to Mount Vernon. Today, a hike and bike trail parallels the road and is used by thousands of tourists and local people on a weekly basis. (PP.)

A model of the proposed parking area and circle drive to Mount Vernon was constructed, as shown here in 1931. (NARA.)

Shown here at the end of construction in 1932, the new parking lot and circle in front of the gates completely eliminated any evidence of the old electric trolley line. The Tea Room can be seen on the new circle drive. (PP.)

By the mid-1930s, the Tea Room had been torn down and a new gift shop and restaurant had been added. The gift shop has recently been turned into a large gift center with food court and bookstore. The Mount Vernon Inn is still in much of its original 1930s-era condition. (PP.)

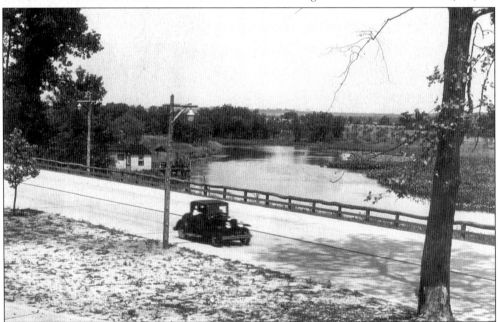

The building of the George Washington Memorial Parkway and new parking lots around the estate transformed the visitation rite to Mount Vernon. Today, hundreds of thousands of tourists flock to pay homage to George Washington's home and tomb as well as learn about one of the most intact and well-documented 18th-century Virginia plantations. (PP.)

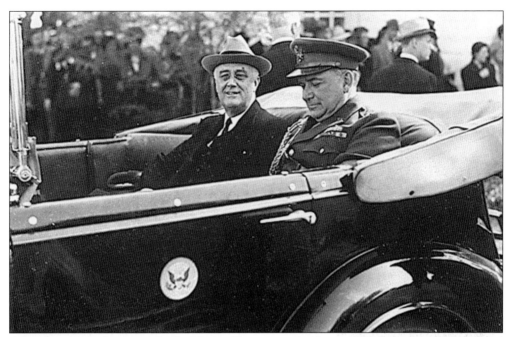

After the new highway was built, Mount Vernon received even more visitors and dignitaries than before, such as President Franklin Roosevelt, shown here in 1935. (PP.)

SLOW
YOU ARE
APPROACHING
MT. VERNON

So the next time you go to Mount Vernon, take your time, look at the surrounding countryside, and reflect on the history that has occurred not just around Mount Vernon the mansion, but also the rich history that transpired outside the gatehouses. As this 1930s sign reads, "Slow, you are approaching Mount Vernon." (PP.)

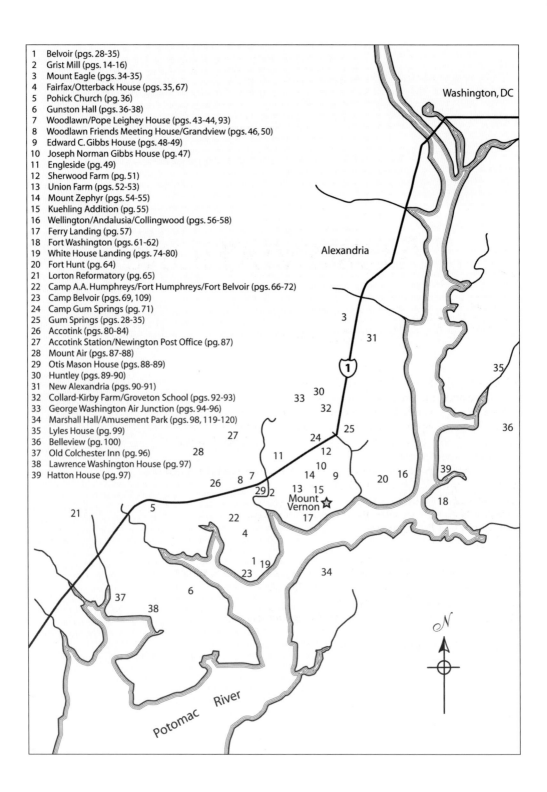

Washington, DC

Alexandria

Mount
Vernon

Potomac River

N

ABBREVIATIONS

AL = Alexandria Library
DR = David Rumsey Map Collection (online)
FB = Fort Belvoir
FCA = Fairfax County Archives
FCPC = Fairfax County Planning Commission
FJS = Fred and Julia Shields Collection
GM = Geography and Map Division, Library of Congress (online)
GSMCC = Gum Springs Museum and Cultural Center
JGL = Joan Gibbs Lyon Collection, Fairfax County Public Library
LC = Library of Congress
MCS = Mayo and Connie Stuntz, authors of *This was Northern Virginia*
MHC = Marjorie Lee Hadlock Collection
MV = Mount Vernon Ladies' Association
NARA = National Archives Record Administration
NPS = National Park Service
PO = Patrick O'Neill
PC = Patricia Close Collection
PP = Prints and Photograph Division, Library of Congress (online)
RGC = Ray Gallagher Collection at Fort Belvoir
RP = Graphic by R. Randall Patrick
VR = Virginia Room, Fairfax County Public Library
WL = Woodlawn
WMH = Woodlawn Meeting House

This 1891 advertisement shows the reproductions of George Washington's original
paraphernalia that was available over 100 years ago! (LC.)